THE ART OF D

MANGA

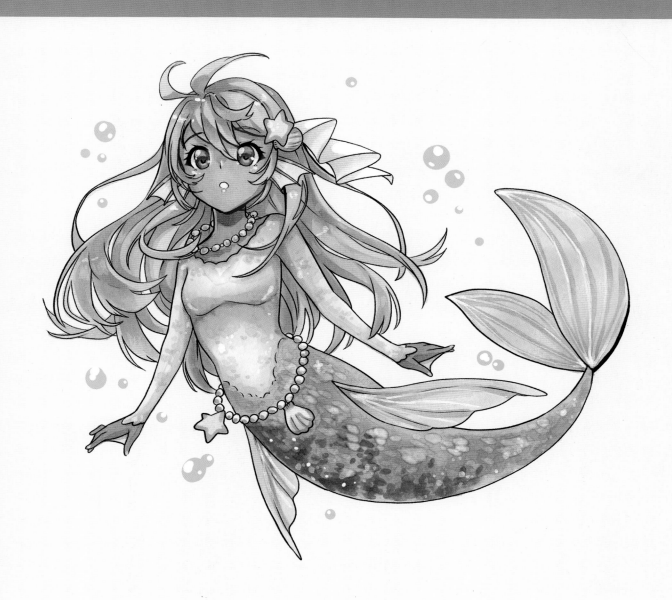

Walter Foster

Inspiring | Educating | Creating | Entertaining

Brimming with creative inspiration, how-to projects, and useful information to enrich your everyday life, quarto.com is a favorite destination for those pursuing their interests and passions.

© 2022 Quarto Publishing Group USA Inc.
Text and illustrations © 2022 Talia Horsburgh

First published in 2022 by Walter Foster Publishing, an imprint of The Quarto Group. 100 Cummings Center, Suite 265D, Beverly, MA 01915, USA. **T** (978) 282-9590 **F** (978) 283-2742 **www.quarto.com** • **www.walterfoster.com**

Walter Foster Publishing titles are also available at discount for retail, wholesale, promotional, and bulk purchase. For details, contact the Special Sales Manager by email at specialsales@quarto.com or by mail at The Quarto Group, Attn: Special Sales Manager, 100 Cummings Center, Suite 265D, Beverly, MA 01915, USA.

ISBN: 978-0-7603-7544-0

Digital edition published in 2022
eISBN: 978-0-7603-7545-7

Proofreading by Savannah Frierson, Tessera Editorial

Printed in China
10 9 8 7 6 5 4 3 2 1

THE ART OF DRAWING
MANGA

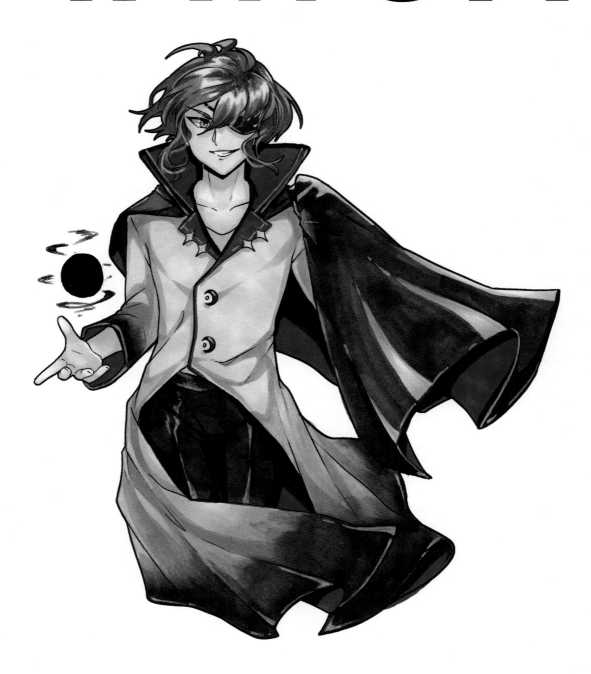

Talia Horsburgh

CONTENTS

INTRODUCTION....................6

CHAPTER 1: THE BASICS8

Tools & Materials10

Common Styles12

Common Genres13

Black & White Art14

Adding Color..........................16

CHAPTER 2: FACES & HAIR........20

Facial Features22

Expressions28

Hairstyles32

CHAPTER 3: ANATOMY & POSES..36

Bodies38

Character Poses46

Clothing & Accessories52

CHAPTER 4: CREATURES58

Pets60

Magical Creatures.....................64

Mascots76

CHAPTER 5: CHARACTER DEVELOPMENT80

Heroes...............................82

Villains90

Sidekicks98

CHAPTER 6: FULL SCENES.........102

Drawing Environments....................................104

Scenes, Step by Step.....................................108

CHAPTER 7: MAKING YOUR OWN ..116

Making a Manga Book..................................118

Sequences, Step by Step..........................124

Developing Your Style...............................132

CHAPTER 8: TEMPLATES136

Heads...138

Standing Body Poses...............................139

Action Poses ..140

Hands & Feet...142

Chibi Poses ...143

ABOUT THE ARTIST.................144

INTRODUCTION

Welcome to the ultimate manga drawing guide for all skill levels! *Manga* is the name for Japanese comic books and translates to mean "whimsical pictures." A unique feature when reading manga comics is that, due to Japanese being read from right to left, manga speech bubbles and panels are also set from right to left. The style itself is well known for its large, expressive, and stylistic eyes; simplified details; bold colors; and diverse genres. Each manga artist, known as a mangaka, makes their own unique stylistic choices to personalize their manga, making no two artists the same.

Throughout this book, you'll see Aya and Shun pop up (sometimes in different manga styles) to give you helpful tips and tricks on drawing and coloring people and animals, developing intriguing characters, creating scenes and action sequences, writing stories and dialogue for a manga book, and much more. Whether you have been drawing manga for years or would like to try the style for the first time, there is something in this book for you!

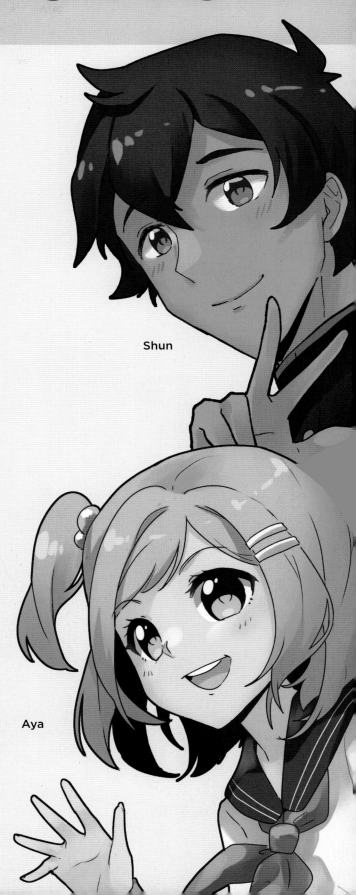

Shun

Aya

Chapter 1
THE BASICS

TOOLS & MATERIALS

The great thing about manga art is your setup can be as inexpensive and simple as a piece of paper, a pencil, and an eraser! This is really all you need to start practicing. As you grow more confident in your art, don't be afraid to branch out and try different media and paper. Below are some different options to create manga illustrations with traditional media.

PENCILS

It is always helpful to have graphite pencils of a variety of densities. Make sure your pencil kit includes a light shade (2H), a medium shade (HB), and a darker shade (2B–6B). A popular choice for many mangaka is a mechanical pencil, which allows for different lead thicknesses and colors. Try different pencils and see what works best for you.

INK

Inking is an important part of the manga process, both as a major part of illustrating manga comics as well as the preparation stage for coloring. Manga artists like to use fine-line pens or dip pens for this stage. When using liner pens, make sure to have a variety of thicknesses. A great nib thickness range is from 0.03 to 0.5 or above, plus a brush pen. Many art supply stores sell these in ready-made sets to make starting your collection easier.

Traditional manga illustrators use dip pens with interchangeable nibs. The most popular nibs for manga artists are the kabura pen for straight lines, G-pen for diverse thick and thin lines, and maru pen for extremely thin lines. If you are a beginner at inking, try liner pens first, and then move on to dip pens once you become more confident.

COLORING TOOLS

Four popular coloring media for manga are alcohol markers, watercolor, gouache paint, and colored pencils. Alcohol markers are a popular choice among mangaka for their superior blending and color range. Use watercolor for backgrounds and light, transparent elements. Gouache is more opaque than watercolor and can be used for any part of an illustration. White gouache is often used for highlights and finishing touches. Colored pencils are the perfect finishing layer on top of paint and markers to add deeper coloring blends and textures to your piece. Experiment with them and see what you love!

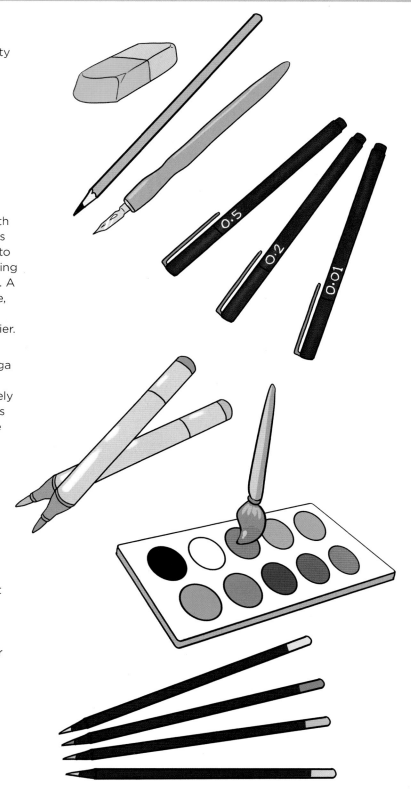

PAPER

Choose your paper depending on the medium you are using. Unless practicing, avoid using generic printer paper. Wet media such as watercolor or markers will need thicker paper, as opposed to dry media such as colored pencils. Mixed-media paper is a great all-round option if you aren't sure what you need. Use bound sketchbooks for practicing. For in-depth illustrations, use sketchbooks with easy-to-tear paper so you can display your completed drawings.

TABLETS

You can draw manga digitally as well. Generic-use tablets with pens can be used for digital drawing, with more and more drawing apps becoming available at a low cost or even for free. Many web-based manga, such as webcomics, are created digitally, so it doesn't hurt to be versed in both traditional and digital options.

If you'd like to invest in higher-quality digital drawing tools, there are many to choose from. Graphics tablets that connect to computers are very popular, but before investing a lot of money in a graphics tablet, research your options and test some out to make sure the tablet you buy is right for you.

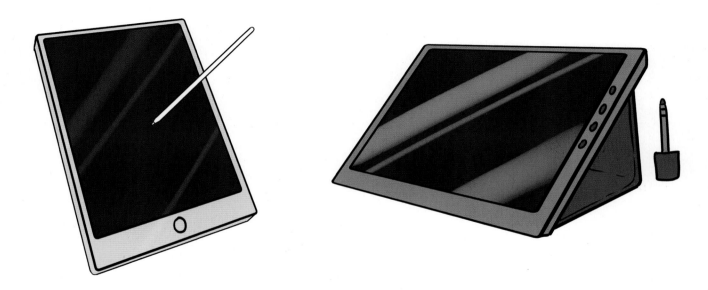

COMMON STYLES

Manga drawing styles are extremely diverse, but there are some common generic styles. The four generic styles are shonen, shojo, realistic, and chibi. You may find yourself switching between these styles before settling on something you prefer.

SHONEN

The word *shonen* translates to "young boy" in Japanese. This style is called shonen because it is commonly used in manga that are aimed toward young teen males. They tend to have male lead characters with lots of action, and the drawing style is usually sharper with bold and bright colors.

SHOJO

Similar to shonen, the word *shojo* translates to "young girl" and is the manga style used in stories marketed to girls and young women. This style is much softer both in the drawing application as well as the colors chosen. These stories are often based around themes such as romance and have strong female leads.

REALISTIC

Although not a dominant style in manga art, slightly stylized realism is commonly seen in genres for older audiences, particularly in horror and action. This style can now be found throughout all genres, as more manga artists have emerged who prefer the realistic style.

CHIBI

Chibi translates to "small" or "short" and is a fun style common in comedy manga or stories for younger children. It is characterized by exaggerated proportions, with large heads and eyes accompanied by small bodies. The faces are very expressive.

COMMON GENRES

A wonderful part of reading, writing, or drawing manga is that there are so many genres to choose from. You can create any kind of story you want, from realistic to fantastical.

FANTASY

Fantasy is a hugely popular genre in all media, and manga is no exception. You can have fantasy creatures, people, vehicles, and even entire worlds. A manga creator's world-building creativity can shine in this genre!

SLICE OF LIFE

The slice-of-life genre is all about the beauty of everyday life and features normal people in believable situations. The reader can't help but root for the main character and whatever they want to achieve. This genre is usually paired with romance or comedy.

MAGICAL GIRLS & GUYS

A branch of the fantasy genre in manga is magical girl or guy. These plots are usually a marriage of slice-of-life and fantasy genres. Powers are bestowed upon normal characters who then become fantastical beings. These characters achieve amazing feats such as saving the world.

ROMANCE

Romance is a theme often central to slice-of-life manga stories. However, a good romance story can be found in almost every genre.

ACTION

Thrilling action, both of a fantastical or believable nature, is a staple found in many popular manga series.

COMEDY

The comedy genre is usually set in normal, everyday life. These stories revolve around comical, weird, or crazy situations and tend to have highly stylized art to assist its comedic and light-hearted nature.

SPORT

Many successful and interesting manga stories have based their characters and plots around different sporting activities. Volleyball, basketball, soccer, and swimming have been the basis of quite a few manga and anime series.

BLACK & WHITE ART

An important part of the manga creation process is line art and inking. But what are they, and is there a difference? Well, the answer is yes, there is a difference. Line art is involved in inking, but inking isn't necessarily involved in line art. More on this below!

INKING A DRAWING

Line art is the stage after sketching in which you use a liner pen or dip pen to outline the lines of the drawing that you want to keep. After applying line art, you erase your sketch and are left with beautiful, clean lines minus all the guidelines used when first sketching. This is then taken into the coloring stage or the inking stage.

Inking is used when creating black-and-white manga panels with blocked-in shadows and dark colors with solid black. This is to enhance the depth of the drawing when color cannot be used to do that.

Here is a breakdown of this line art and inking process.

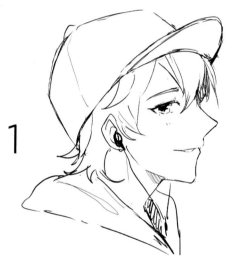

1

Complete your sketch and tidy it up. The neater the sketch, the easier lining will be. There's nothing worse than going in with a pen not knowing which lines you actually want to keep.

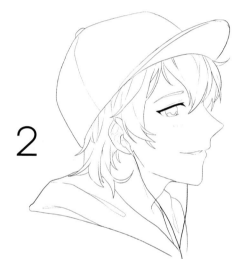

2

Using a thin liner pen or nib, trace over the lines you want to keep. Make sure you're not holding the pen too tightly or else your lines will come out scratchy and shaky. Have a loose wrist and take your time.

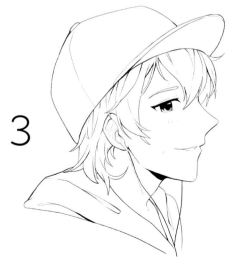

3

To make the line art more dramatic, go in with a slightly thicker pen and darken areas where lines meet or where there is shadow. These usually occur under the neck, around the hairline and in clothing folds. After finishing this stage, you can color or ink it.

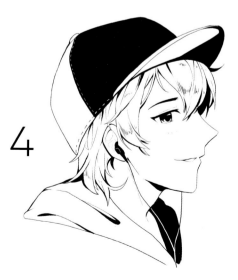

4

To ink a manga story or for black-and white-art, go in with a black brush pen and block in shadows and dark areas or patterns. Make sure to leave some white areas to give contrast and add depth to your drawing. Other shading techniques such as crosshatching or stippling can also be used in inking to produce more natural shading gradients.

SHADING WITH INK

Shading conveys depth and volume in your drawings, making them look more three-dimensional, because you show how light and shadow reflect off of your subjects. There are a few different ways to shade using inks, as shown below.

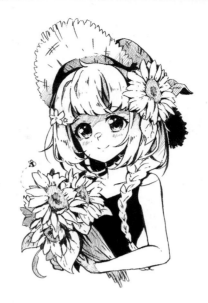

Hatching is good for slightly dark areas.

Crosshatching produces texture and darkens a little more than one-way hatching lines.

Stippling is a time-consuming shading technique but produces natural gradients. To stipple, apply small dots in different densities.

Full black ink is for the darkest parts of the illustration.

ADDING COLOR

Now that you have learned about black and white art, it's time to jump into the wonderful world of color! Before getting into the specifics of coloring techniques, here is a crash course in color theory. This is extremely useful knowledge for any artist!

THE COLOR WHEEL

When choosing color palettes, have a color wheel handy! Knowing the colors' relationships to one another can help inform you how and when to use them in your drawing.

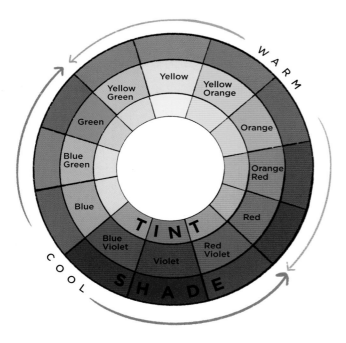

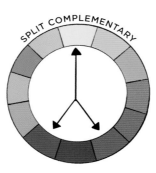

Split complementary colors include the main color and the two colors on either side of the main color's complementary color.

Pros: Quick and easy pallet inspiration.

Cons: Not as much contrast as the complementary color.

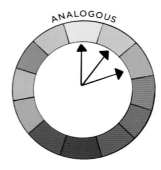

Analogous colors are the ones directly next to your chosen color.

Pros: Analogous colors look pleasing together.

Cons: There is not a high contrast, possibly making it less interesting than other color choices.

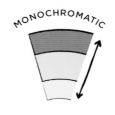

Monochromatic colors are the various tints, tones, and shades found in a single hue (color).

Pros: An easy-to-manage color choice, monochromatic colors will always work well with your chosen color.

Cons: With limited contrast, this color choice could become visually uninteresting.

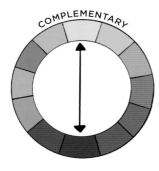

Complementary colors are directly opposite each other on the color wheel. When mixed together, these colors create "true gray."

Pros: Complementary colors have great contrast.

Cons: Because they mix to make gray, the colors can look muddy if they are mixed too much in the drawing.

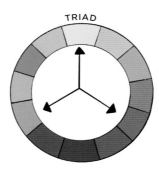

Triad colors are all evenly spaced from each other on the color wheel.

Pros: Triad colors work harmoniously together, while maintaining contrast.

Cons: You will not see as much contrast as with complementary colors.

Words to Know

Hue: A "pure color," which can be found on the color wheel (red, yellow, blue etc.)

Tint: Any hue + white

Tone: Any hue + gray

Shade: Any hue + black

Warm: These colors include reds, yellows, and oranges. When applied to a drawing, warm colors appear closer. If you want parts of a drawing to look closer to the viewer, make the colors warmer.

Cool: These colors include blues, violets, and greens. Cool colors appear farther away, so if you want parts of a drawing to look farther away, add cool tones to it.

A BETTER WAY TO SHADE

Many beginner manga artists shade with monochromatic colors. They choose their base color and add black to the color for shading. Although this does work to an extent, it leaves the drawing looking muddy and not as intense or interesting as it could be. Instead, when choosing a color for shading, slightly change the hue and then use a shade of that color. For example, if your base color is yellow, rather than just using a "darker" yellow, move to yellow-orange and then find a shade color from there.

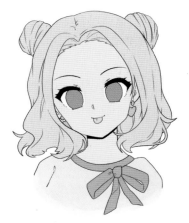

Base Color

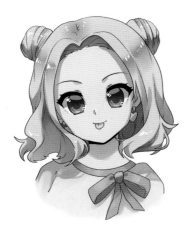

Monochromatic Shading

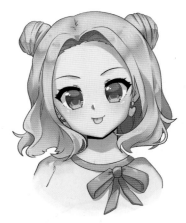

Shading with Hue and Tone

Both of these drawings have the same base color (shown on left). The middle image was colored with monochromatic colors and looks bland and dull when compared to the right-most image. This image was shaded with slightly warmer and cooler hues than the base color. Although the change is small, the outcome is totally different!

Color Palette Inspiration

Spring Palette

Summer Palette

Fall Palette

Winter Palette

Pastel Palette

Skin Tones Palette

COLORING TRADITIONALLY

There are many ways to work when coloring traditionally, depending on the medium you prefer using. Follow along with the villain step-by-step drawing project on page 92 to see in-depth instructions for coloring with alcohol markers. Here are some tips to help you color traditionally.

- Try as many different media as possible. As the saying goes, "You'll never know until you try it."

- Be aware if the medium you are using is a wet medium or dry medium. Wet media need specific paper and different drying times if you want or don't want colors to blend.

- Don't be too cautious with your sketchbooks. They are designed to be doodled in and ruined all in the name of practice and inspiration. Save your masterpieces for the good paper and canvas.

- Get yourself a drawing board. They help elevate and tilt art at different angles to work on. There is nothing worse than working on a drawing on a flat surface and lifting it up to see you've drawn the perspective all wrong because of the angle of the paper as you worked on it.

- Stand back from your art. We work so closely on our pieces that sometimes standing back and seeing it from a distance helps us find flaws we wouldn't have otherwise seen.

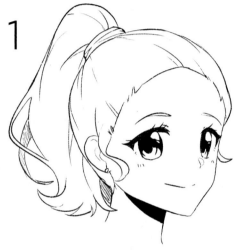

1

Have your line art ready and make sure the ink is dry before coloring.

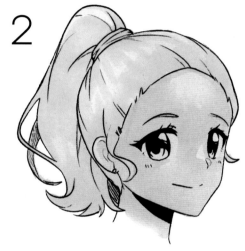

2

Color in the lightest colors for the base. Leave areas white where highlights will be.

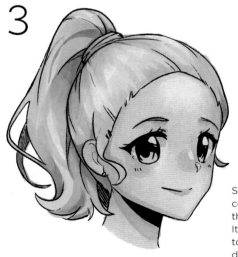

3

Shade the base color, still leaving the white highlights. It's usually easiest to work light to dark, but that can change depending on the drawing, so use what method works best for you.

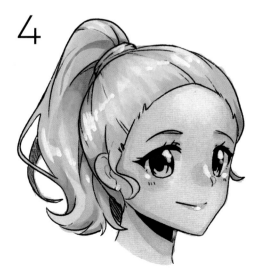

4

With ink or gouache, paint in the highlights on hair, skin, and eyes.

COLORING DIGITALLY

If you'd like to get into drawing digitally, below you'll find some tips and tricks to help get you started. See the hero drawing project on page 84 for step-by-step digital coloring instructions.

- Choose a device that works well for you. If you already have a tablet you can draw with, start with that. There is no need to go and spend the big bucks until you have tried it out to see if digital art is for you.

- When choosing a canvas size to work with, always use 300 dpi and a canvas of at least 2,000 x 2,000 pixels. The larger the canvas, the less pixelation you will get and the crisper the lines will be.

- Layers are your friend! A good drawing program will allow you to add layers to draw on. Make sure your line art and colors are on different layers to allow easier editing. That's the best part about digital art! That and the undo button.

- Play around with layer properties. Layers can be set to different properties like multiply, screen, and overlay, to name a few. These all do different things to the colors in the layer, so play around with it.

- Try all of the brushes available to you in the program. Sometimes we find a brush we love and use it forever. This can limit your art if you never mix it up with other brushes.

- The holy grail of layers is the clipping layer. If you set a layer to clipping mode, it will only draw within what you drew on the layer below. This allows you to change the color of your line art, shade within a certain color, and much more.

- If you find your lines are shaky and messy, try turning up the stabilization setting on your brush. This allows for smoother lines and is perfect when doing line art.

- Remember that when you work digitally, colors are shown in RBG (red, blue, and green), as these are the colors that screens use to project an image. However, in real life we can only print in CMYK (cyan, magenta, yellow, and black), which naturally dulls the colors you may be used to seeing on your screen. If you want to print your work and avoid this difference, make sure to set the preview in your program to CMYK and not RBG. This will automatically shift the colors to look similar to how it would look when printed.

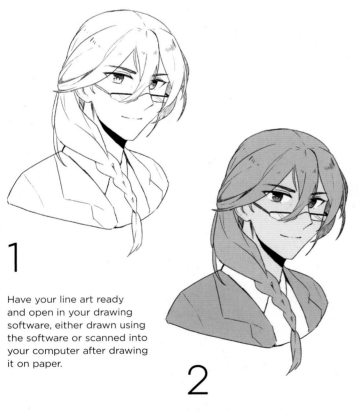

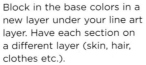

1

Have your line art ready and open in your drawing software, either drawn using the software or scanned into your computer after drawing it on paper.

2

Block in the base colors in a new layer under your line art layer. Have each section on a different layer (skin, hair, clothes etc.).

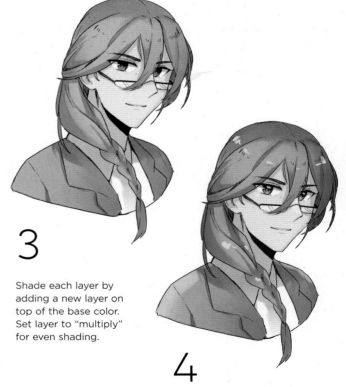

3

Shade each layer by adding a new layer on top of the base color. Set layer to "multiply" for even shading.

4

Add in highlights and any extra shadows, and you are all done!

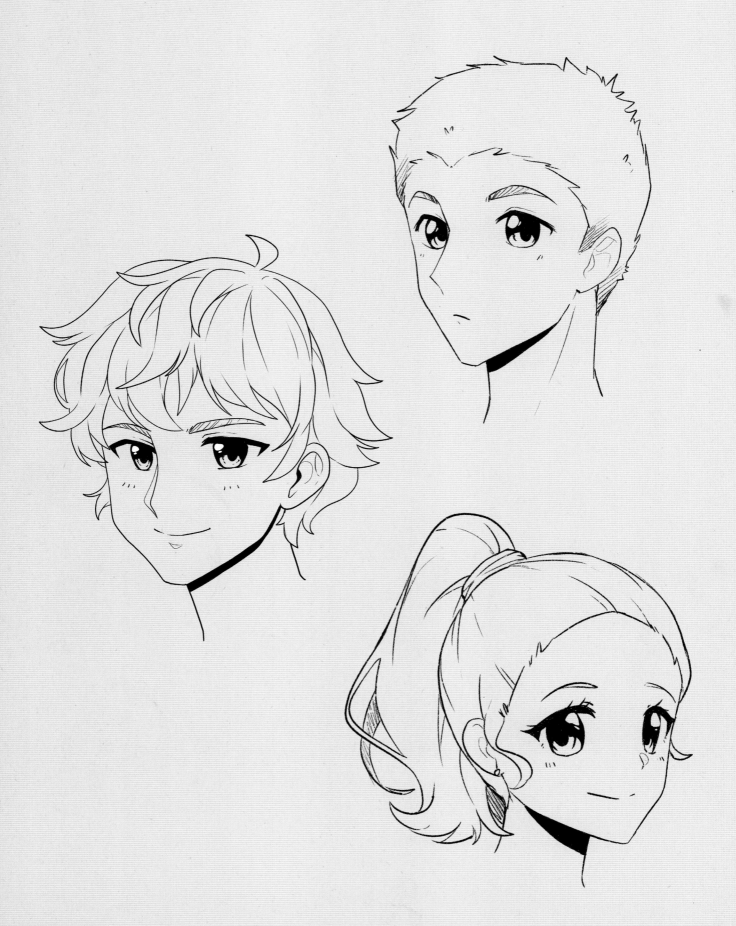

Chapter 2

FACES & HAIR

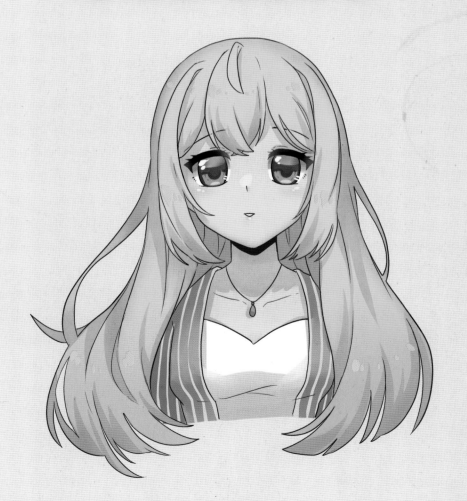

FACIAL FEATURES

In this section, you will learn how to draw the face from different angles and at different ages. Even though you are not drawing in a realistic style, using reference and observing people's faces will help you create better manga drawings.

EYES

It's crucial to know what something looks like in real life and to understand how it works before stylizing it. This is especially true for eyes because they are so expressive. Study how a real eye looks at different angles, and your manga eyes will improve!

Once you understand these elements, have some fun! Play around with the size and shape of the eyes, and try to draw different emotions or expressions. Make expressions in a mirror, and pay close attention to what you see and what muscles you feel in your face.

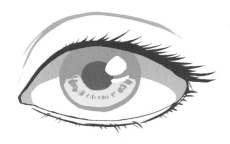 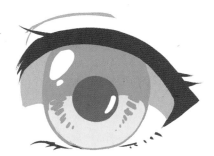

Large, expressive eyes have become one of the most notable features of the manga drawing style. See what makes a manga-style eye by comparing the eyes above. The parts of the eye are color-coded to show how all the elements of a realistic eye remain on the manga eye and how they change shape when stylized.

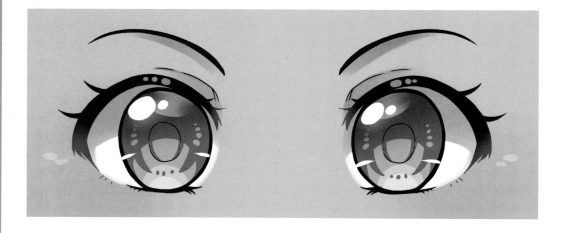

Cute eyes should be round and big with large highlights. Keep edges rounded and soft, which make characters look vulnerable, innocent, young, or beautiful.

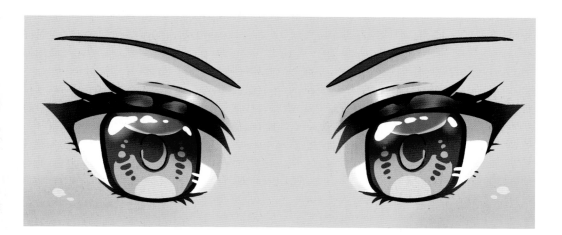

Mysterious eyes have sharper features with limited larger highlights. Avoid overly rounded edges. Darkening the eye color can give off a more mysterious vibe.

Kind eyes are relaxed and soft, with pupils that are round and inviting. If you have a friendly character, start with this eye style.

Determined eyes or even angry eyes, are small and sharp. Having the eyes partly closed but fixed intently on something makes the character look unyielding. The head may be pointing down slightly with the eyes still looking forward. Keep highlights small or avoid them altogether.

On a Side Note

When drawing eyes from the side, the iris thins and changes from circular to oval. Remember that the eye is a sphere, so draw it rounded with the pupil sitting near the back of the iris. Studying eyes in real life with help you to understand this perspective.

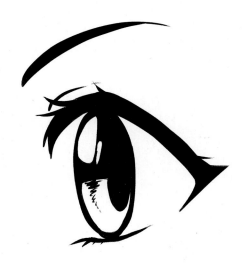

FRONT VIEW

When creating manga, you will draw the same face in many different positions and from many different angles. Once you learn basic drawing steps, and with some practice, you'll be an expert in no time! Jump in by starting with this simple forward-facing character.

Eyes are usually an eye's width apart. In manga this can vary, so use it as a generalized rule.

1

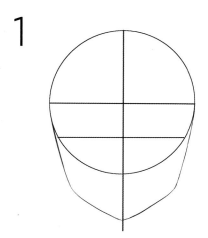

Start sketching with light pencil lines. First draw a circle. Add guidelines as shown above to help you place the facial features. Draw the bottom half of the face by extending lines down at a slight angle from the bottom horizontal line to the chin. Roughly halfway between the bottom of the circle and the chin, angle the lines in so they meet at the middle.

2

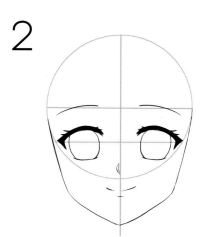

Plot in the main facial features. The top horizontal line is where the eyebrows sit. The line under that is where the eyes are located. Draw the nose in the area where the vertical line and the bottom of the circle intersect. The mouth is halfway between the nose and the chin.

3

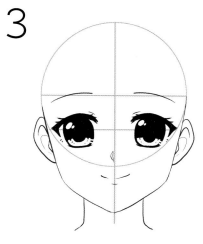

Detail the pupils and then place the ears, which also sit on the eye line. To estimate the neck width, trace a line down from centers of the pupils, and that thickness is a good guide. Add a thicker neck for more masculine characters.

4

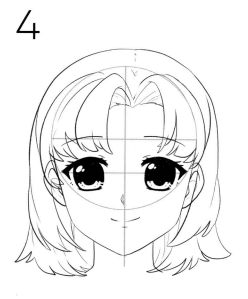

Now draw the hair. Make sure when drawing hair to leave a space between the head and the hair to give it volume. Drawing hair straight onto the head guideline will make the hair appear matted down or wet. (Learn more about drawing hair on pages 32–35.)

5

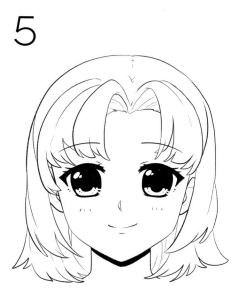

Line the final parts of your drawing and then erase. Practice makes perfect, so if you don't like how your drawing turned out, find where you can improve and try again!

6

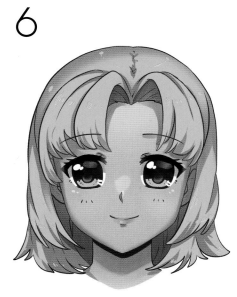

Now add shading and color! Review pages 18–19 for tips on coloring.

THREE-QUARTER VIEW

The three-quarter view is in between a front and profile view. Take this view step by step to draw this slightly trickier pose.

1

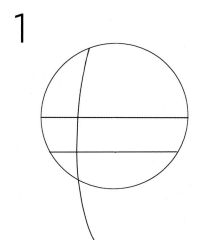

Start off similarly to drawing a face in the front view, except curve the vertical line and shift it off-center to the direction you want your character facing.

2

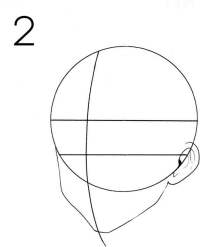

This is probably the trickiest part, drawing the bottom of the face in this view. The side farther away from the viewer will be more rounded, as the cheek can be seen from this angle. We only see one ear in this view. Reference real-life photos of this angle to become comfortable with the perspective.

3

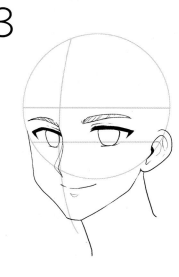

The eyes sit on the lower horizontal line, and the eyebrows somewhere between the eyes and the upper horizontal line. The nose sits in the area where the vertical guideline line and the circle intersect. The mouth is roughly in the middle between the nose and chin.

4

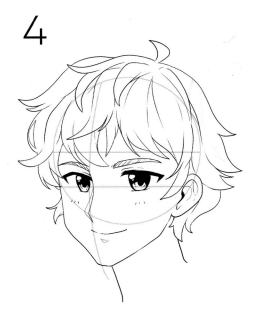
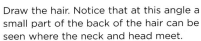

Draw the hair. Notice that at this angle a small part of the back of the hair can be seen where the neck and head meet.

5

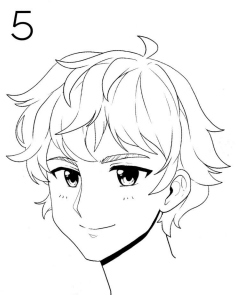

Ink the final parts of your drawing and erase the guidelines.

6

Add shading and color. Congratulations! You have drawn a three-quarter-view manga face.

SIDE VIEW

In the side or profile view, the nose and mouth take center stage, which makes this angle a bit tricky at first. Thankfully, as always, guidelines help when drawing this perspective. Once you are comfortable with drawing simple faces, try different facial expressions (see pages 28–31) or making a character younger or older (see next page).

1

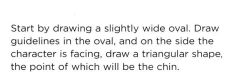

Start by drawing a slightly wide oval. Draw guidelines in the oval, and on the side the character is facing, draw a triangular shape, the point of which will be the chin.

2

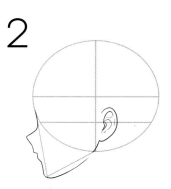

Using the lines drawn in step 1 as a guide, draw the nose and lips. The bridge of the nose starts in line with the lower horizontal guideline, and the mouth sits between the nose and the chin. Place the ear slightly behind the vertical guideline and on the lower horizontal guideline.

3

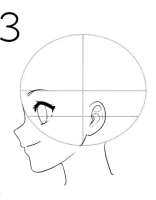

Place the eyes, eyebrows, and mouth. Refer back to pages 23 if you find drawing an eye from the side tricky.

4

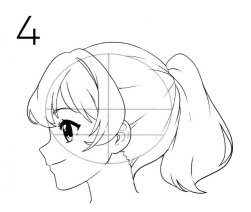

Draw the hair. Because you can see the back of the character's hairstyle at this angle, it's a great way to show off what their hair looks like.

5

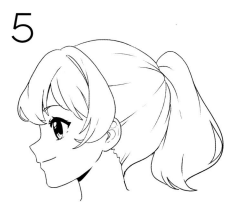

Ink the final parts of your drawing, and erase the guidelines.

6

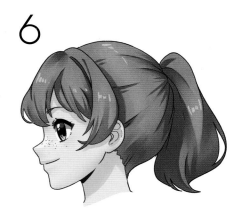

Add color and shading, and you now have a side view of a manga face.

If you find your original guidelines are off when placing the facial features, erase and try again! Now is the best time to rework as much as you want because once you have lined the drawing, there is no going back.

AGING FACES

Knowing how to draw characters of all ages gives you more creative freedom when making your own manga and designing characters. Here are some subtle and obvious changes to make when drawing a character's face at different phases in their life.

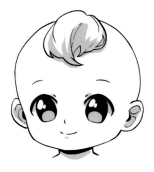

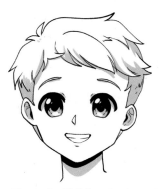
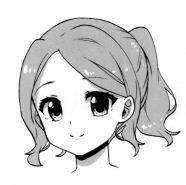

Stage 1: Baby to Toddler

When drawing babies and young kids, think round (round head, round eyes, and round and chubby bodies and cheeks). The proportions at this stage favor the eyes, so make them nice and big to enhance the "cute factor." The facial features sit lower on the head, giving them a large forehead.

Stage 2: Child to Preteen to Teen

As the character grows up, the face lengthens out and facial features sit higher up on the face. Keep eyes and ears fairly big, as the characters are still growing into their bodies. Heads remain pretty round at this stage but with a more defined jawline.

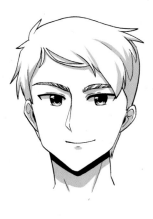
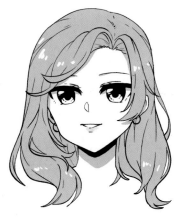
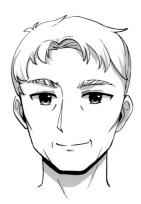
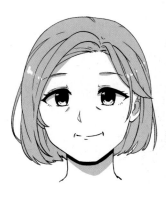

Stage 3: Older Teen to Young Adult

As a character reaches adulthood, lengthen out the head and define the jawline even more. Men usually have longer faces and more defined jaws than women, but of course this isn't always the case. Eyes are also smaller and sit slightly higher on the face to compensate for the longer head length.

Stage 4: Adult to Middle Age

At this age, which spans for several decades (late 30s to 50s), characters gain a few wrinkles and aging lines. Small lines under the eyes and around the mouth hint to this aging. Also consider the hair as it thins and grays. Jawlines also become less defined and faces round out slightly.

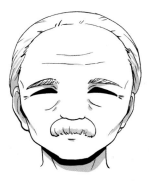
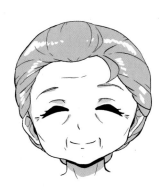

Stage 5: Mature to Old Age

As characters reach their golden years, proportions start to mimic stage 1. Heads grow rounder and facial features sit lower, but this time with wrinkles. At this age, men may be balding or be completely bald, and women usually sport more conservative and simple hairstyles. It's common in manga to draw older characters with their eyes shut as a symbol of advanced age rather than a literal depiction.

EXPRESSIONS

Expressive faces are a key feature in manga and give characters life and relatability. There are hundreds of subtleties in facial expressions, which you will begin to notice as you continue to observe and draw. Begin here with some of the most commonly used expressions in this drawing style.

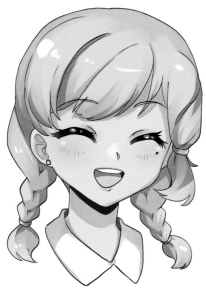

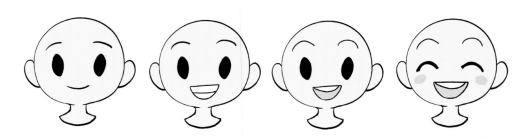

HAPPY

Joyful expressions tend to be the default when drawing characters. The wider the smile, the more emphasis there is on the emotion. If a character is extremely happy, they may even have their eyes closed because their smile is so big.

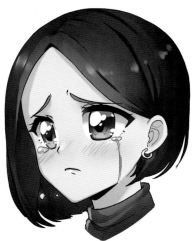

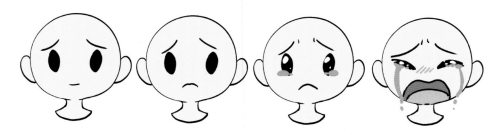

SAD

Pay attention to the eyebrows when drawing a sad character. A character can be smiling, but if the eyebrows are low and furrowed in the middle, the emotion changes dramatically. If the character is crying, the nose and cheeks become red as a result. Eyes that are about to cry or are crying will have lots of white highlights to represent the tears building and making the eyes wet.

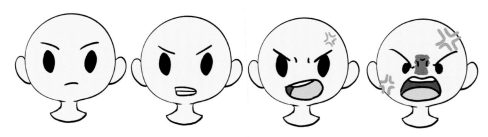

ANGRY

Anger appears in the mouth and eyebrows especially, but there are many ways to show anger on a face. The character could be quietly scowling in the corner or in the middle of the action, yelling at someone. The stronger the anger, the redder the face, as blood rushes to the head. A common way to show frustration and anger in manga is including the stylized vein throb on the head.

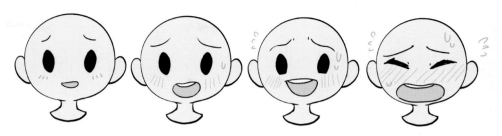

SHY

Shyness is a more subtle emotion and can combine with other feelings, such as being anxious, nervous, flustered, or embarrassed. A shy character is usually blushing and will have furrowed eyebrows. They also may be smiling or frowning, depending on the situation.

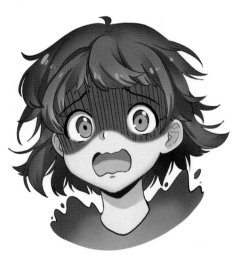

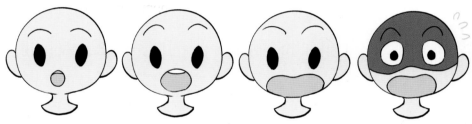

SHOCKED OR SCARED

The shocked or scared expression is a fun one to draw in the manga style. To depict these expressions, focus on making things big. Give your character an open mouth and wide eyes, and for added flair, make the hair jump up too. A common stylization choice used in manga is to shade the top part of the face to show fear, uncertainty, or disgust.

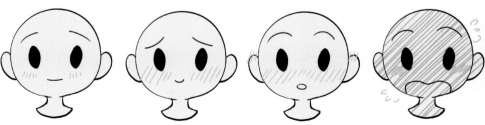

EMBARRASSED

You will see this expression a lot in romance manga stories. Similar to the shy expression, the embarrassed expression relies on lines on the face. For extra effect, these sometimes cover the entire face and even the ears!

EXTRA EXPRESSIONS

Here are a few more popular expressions to try out on your next drawing.

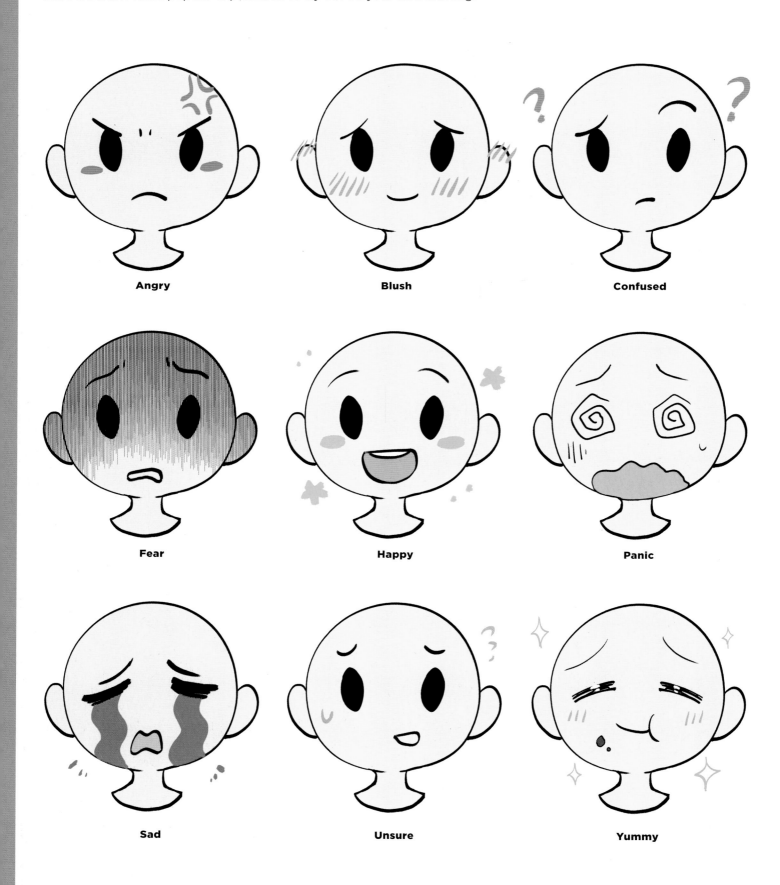

Angry

Blush

Confused

Fear

Happy

Panic

Sad

Unsure

Yummy

MOUTH & EYEBROW IMPORTANCE

To see how important the eyebrows and mouth are in a drawing, look at this example of a face that just has these two elements change. The shape and placement of these features greatly affect the expression. By altering the eyebrows and mouth only, you can achieve many different emotions.

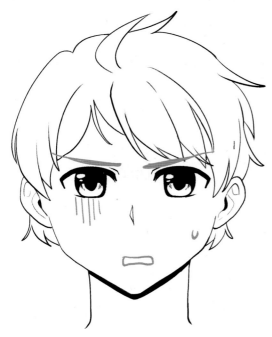

Disgusted expressions display the eyebrows close to the eyes and the mouth farther down on the face than usual. Two common manga emotion symbols are also on this face, the sweat drop, used to show emotions such as nervousness and uncertainty, and lines under the eye, which can portray fear or sickness.

Jealous faces feature angry and determined-looking eyebrows with the inner corners lowered toward the eyes. There are blush lines in reference to being angry, upset, or embarrassed. The mouth is a small frown and drawn higher than usual. This effect is similar to a character who is pouting or feeling wronged.

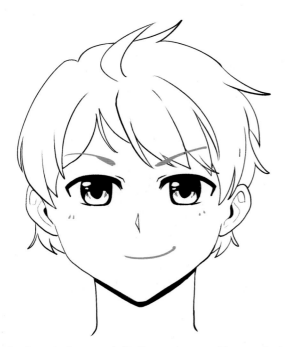

Smug looks pair downward-slanting eyebrows with a crooked smile. Prideful and egotistical characters often wear this facial expression.

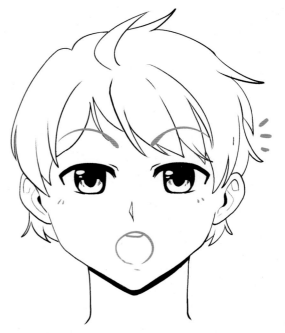

Surprised expressions often have high eyebrows and a wide-open mouth. The three lines coming from the side of the head represent that something has gotten his attention, which we can assume is the reason for his expression.

HAIRSTYLES

A character's hairstyle is one of the best ways manga artists can hint at personality and personal style. Hair can convey if a character is flamboyant, conservative, outgoing, or practical. When learning to draw hair, the first thing to consider is how to actually place it on the head.

DRAWING HAIR

When first drawing hair, many artists tend to want to draw every little hair on the head. Doing this will only make the hair look messy and will be a visual overload for the viewer. Instead, imagine hair sections as if they were ribbons. Study how a ribbon falls and curls, and you'll see that this is very similar to how hair also falls and curls. Draw in some stray hairs as well as some negative space within the ribbon shapes, as hair isn't one big mass, and before you know it, you will have drawn believable and visually pleasing hair!

Hair Placement

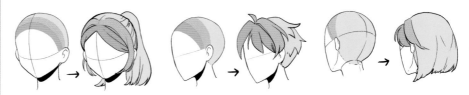

When drawing hair, break it down into three sections: the front (pink), midsection (blue), and back (yellow). The front is where the bangs or any hair at the front sits. The hair that frames the face and goes over the ears is found in the midsection. The back section is the main bulk of the hair that will either grow out long, stay short, or be put into a hairstyle.

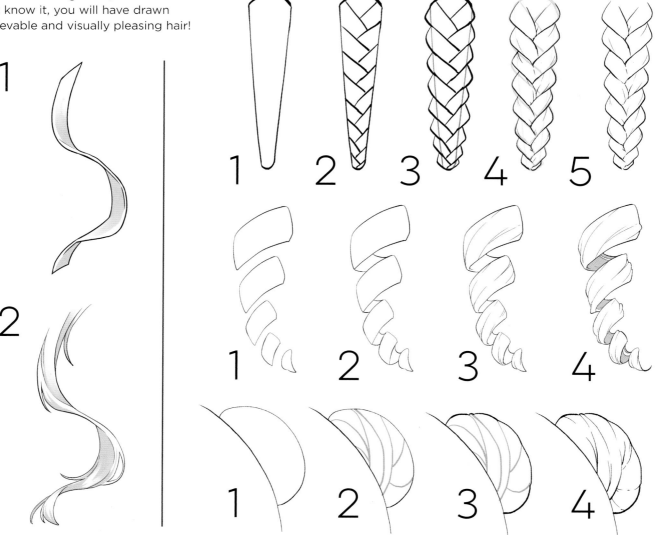

Long hair looks beautiful, but sometimes artists can get carried away and get lost in all that hair! Break it down and focus on smaller sections one at a time. Have the odd strand come away from the main group and then reconnect farther down to add intrigue and motion to the hairstyle.

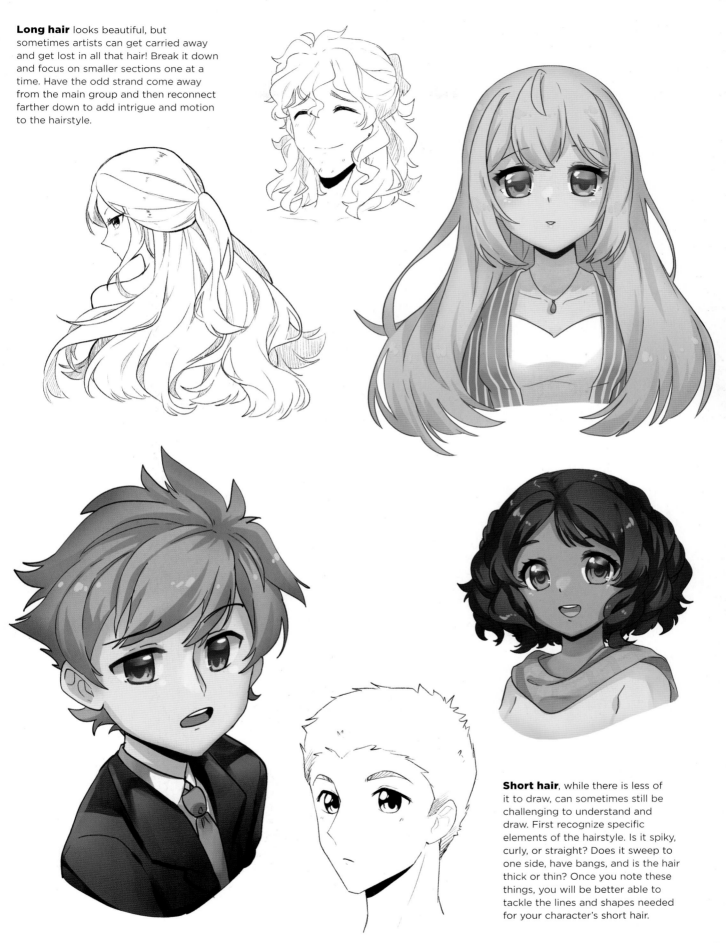

Short hair, while there is less of it to draw, can sometimes still be challenging to understand and draw. First recognize specific elements of the hairstyle. Is it spiky, curly, or straight? Does it sweep to one side, have bangs, and is the hair thick or thin? Once you note these things, you will be better able to tackle the lines and shapes needed for your character's short hair.

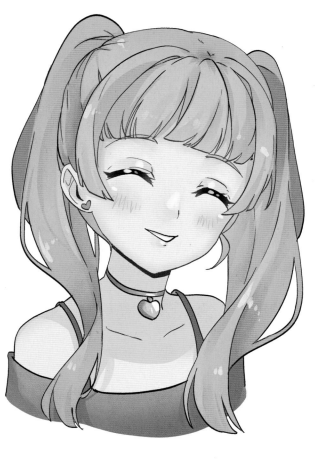

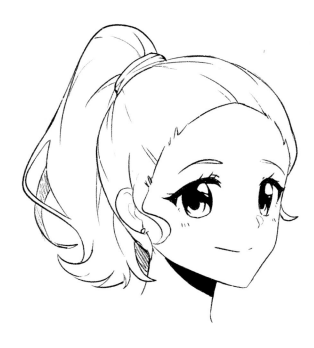

Ponytails and twin tails will have tight hair in the back section directed to the point where the hair is tied up. When there is more than one point, such as in twin tail styles, there is a part in the hair, usually down the middle, to separate both sides. After the tie, hair can fall downward as long hair does.

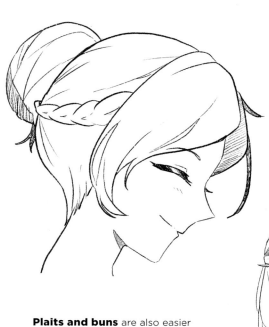

Plaits and buns are also easier to draw when broken down into smaller sections and then built on top of those guidelines.

HAIRSTYLE VARIATIONS

Here is a simple way to approach drawing hair and how you can build many different hairstyles off of the same base.

1
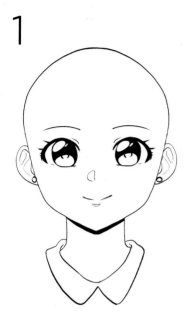

Start with a character with the facial features already placed.

2
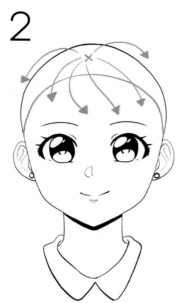

Make a note, either on your paper or mentally, where the main part of hair will originate and what way the hair will sit on the head.

3
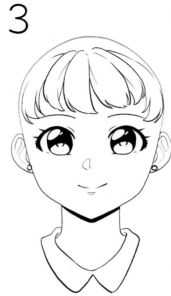

Draw in the fringe or bangs.

4
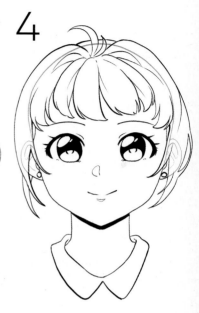

Move on to the midsection and draw the hair that sits at the side of the face. Also draw in the small part of the back of the head that's visible.

5a
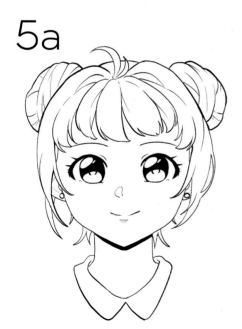

Variation 1 Now draw the back of the hair. This is the first variation, which consists of two cute buns.

5b
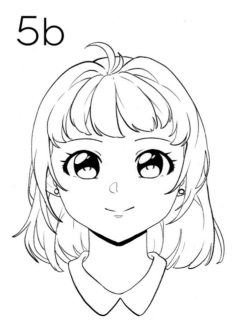

Variation 2 If the character has short hair, draw it simply falling onto the shoulders.

5c
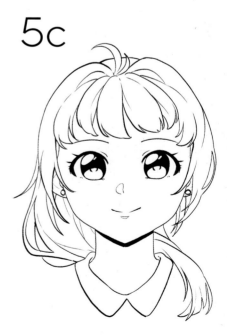

Variation 3 To show off long hair, draw it pulled over one or both shoulders so it is visible to the viewer.

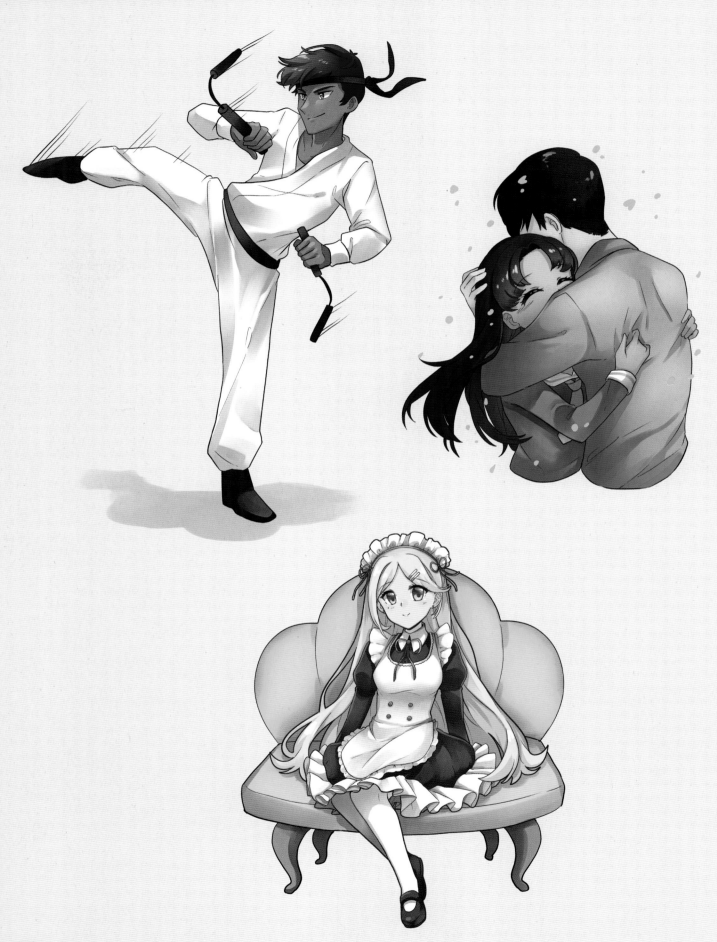

Chapter 3

ANATOMY & POSES

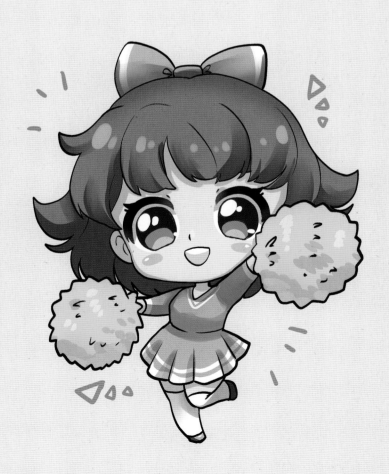

BODIES

When it comes to anatomy, bodies vary for many different reasons, so use this section as a template to start with and not hard and fast rules for everyone. In this section you'll see how bodies change as they age, how the body affects clothing, and how to tackle drawing hands and feet, which are intimidating subjects for some beginning artists.

BODY PROPORTIONS AT DIFFERENT AGES

As we grow, our bodies change in proportion and shape. As manga artists it's important for us to learn what these changes usually are and how to draw them so that our stories can have a wide variety of characters!

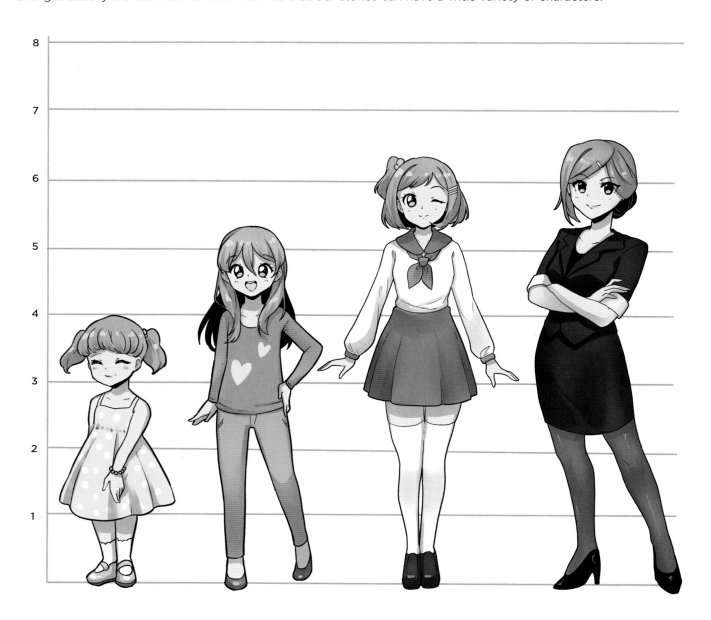

Artists usually base a character's height on how many "heads" tall they are. For small children, the average height is around four heads tall. Once we reach older child or preteen age, it's up to five or almost six heads tall. Teenagers and adults vary from six to seven and a half heads tall. In adult years, the character may grow a very small amount, possibly by a half a head.

Another way to measure height is the ratio between the head, torso, and legs. For small characters such as children, we can use a 1:1:1 ratio. For middle-height characters, that can change to 1:2:2, and for tall characters it can move to 1:2:3.

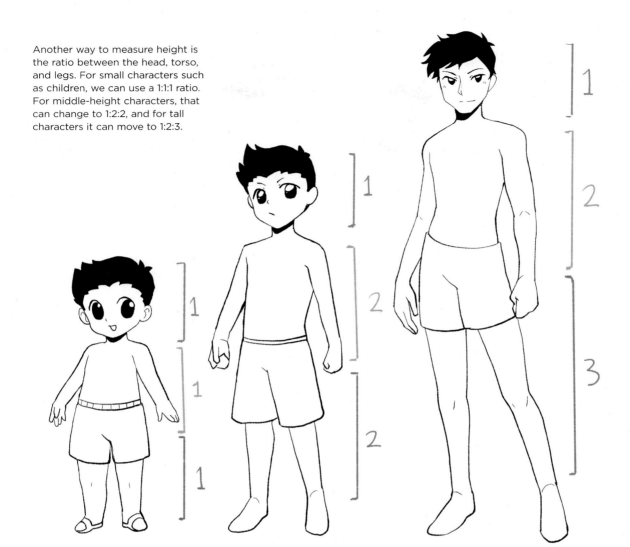

Chibi Proportions

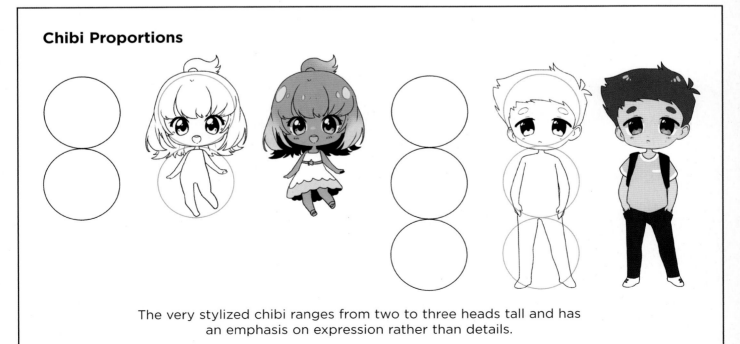

The very stylized chibi ranges from two to three heads tall and has an emphasis on expression rather than details.

FULL BODY

As daunting as a full body drawing may seem at first, just take it one step at a time, and you'll find drawing a full character isn't as hard as it may first appear! This character is six heads tall and, as an adult, has a 1:2:3 proportion.

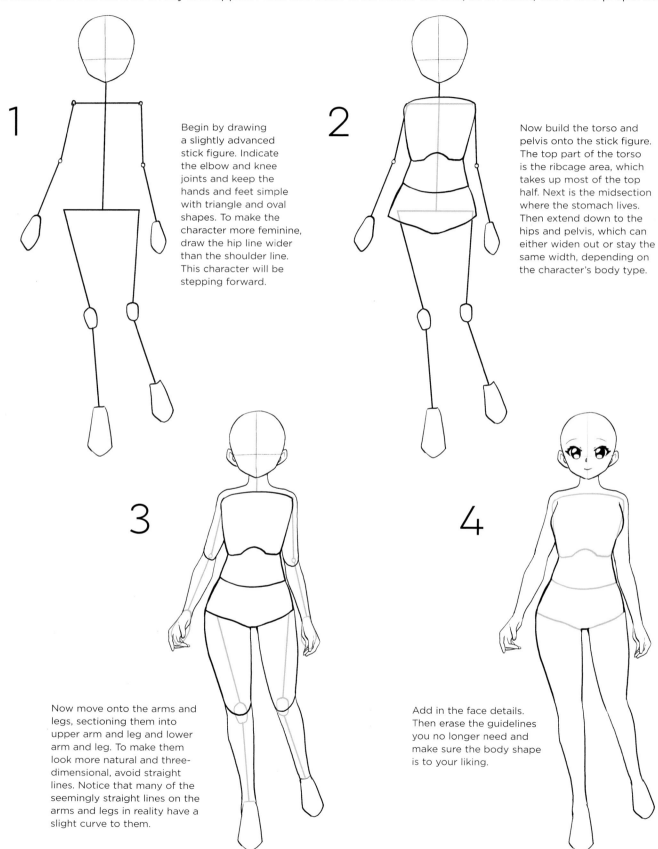

1 Begin by drawing a slightly advanced stick figure. Indicate the elbow and knee joints and keep the hands and feet simple with triangle and oval shapes. To make the character more feminine, draw the hip line wider than the shoulder line. This character will be stepping forward.

2 Now build the torso and pelvis onto the stick figure. The top part of the torso is the ribcage area, which takes up most of the top half. Next is the midsection where the stomach lives. Then extend down to the hips and pelvis, which can either widen out or stay the same width, depending on the character's body type.

3 Now move onto the arms and legs, sectioning them into upper arm and leg and lower arm and leg. To make them look more natural and three-dimensional, avoid straight lines. Notice that many of the seemingly straight lines on the arms and legs in reality have a slight curve to them.

4 Add in the face details. Then erase the guidelines you no longer need and make sure the body shape is to your liking.

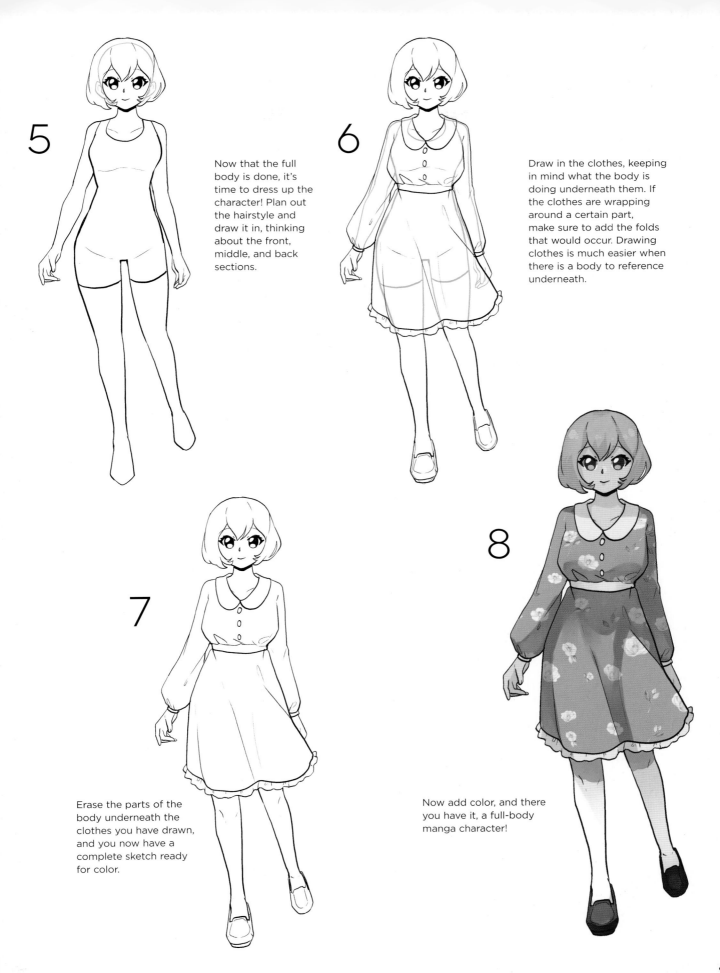

5 Now that the full body is done, it's time to dress up the character! Plan out the hairstyle and draw it in, thinking about the front, middle, and back sections.

6 Draw in the clothes, keeping in mind what the body is doing underneath them. If the clothes are wrapping around a certain part, make sure to add the folds that would occur. Drawing clothes is much easier when there is a body to reference underneath.

7 Erase the parts of the body underneath the clothes you have drawn, and you now have a complete sketch ready for color.

8 Now add color, and there you have it, a full-body manga character!

CHIBI FULL BODY

One of the gifts given to us by manga and anime is the adorable chibi! Chibi, which translates to "small" in Japanese, are super cute characters. They have fewer details but make up for it with their overly exaggerated features and expressions.

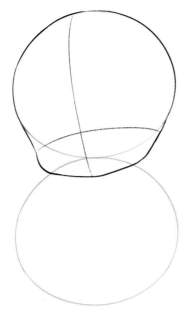

1

Start by drawing in how many heads tall you want your chibi to be. This example is two heads tall. Draw the head shape onto the top circle and add the guidelines for the facial features. Draw the horizontal line for the eyes in the lower part of the head because chibi eyes are bigger and sit lower than in the normal face proportions.

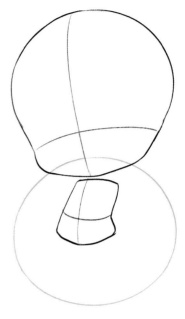

2

In the lower circle, draw the body. The main section of the body takes up roughly half of the area from the chin to the bottom of the circle. Make sure to leave a small gap between the head and the torso.

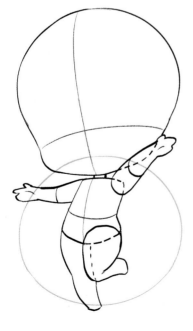

3

Add in the arms and legs. The legs will go down to the bottom of the circle, and the arms will reach out roughly the same distance. The hands and feet are simplified. Add in a small neck to connect the head and body.

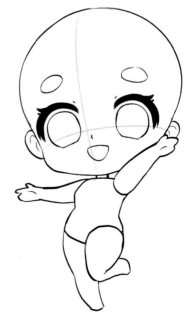

4

Place the eyes on the horizontal line and the nose and mouth just underneath. Some chibi styles omit the nose altogether, so the nose is optional here. The ears sit on either side of the eye line. Feel free to make the eyes as big and expressive as you'd like! Eyebrows can be simplified to small circles to add to the cuteness.

5

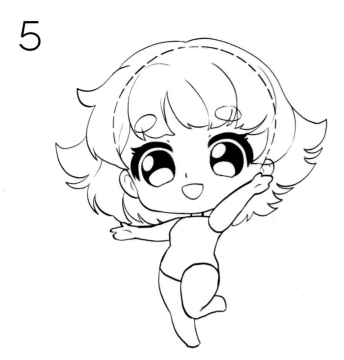

Draw in the hair of the character, making sure to have room between the head and the top of the hair for volume.

6

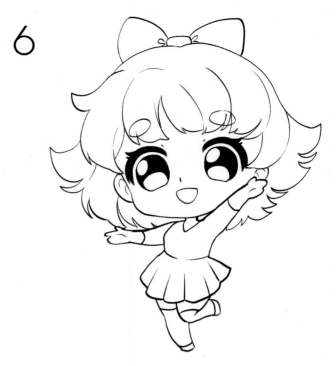

Because the body is so small, you don't need to think about making clothing folds as much as with the more realistic character on pages 40–41. This chibi is a cheerleader, so she does have a pleated skirt.

7

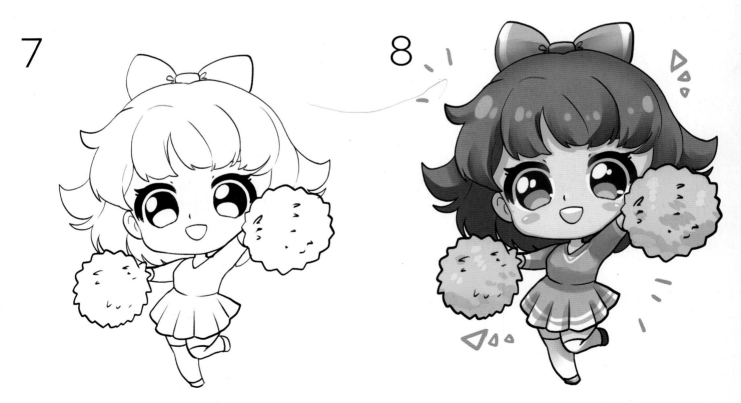

Add any finishing details you need, in this case pom-poms. Then ink the chibi with black pen and erase extra sketch lines.

8

Add color and congratulations! You have now drawn a very cute manga chibi!

REALISTIC HANDS

Hands can be the most challenging and difficult part of the human body to draw. Sometimes artists go to great lengths trying to avoid having to draw them, which only hurts their art in the long run. Start practicing now and approach drawing the hand by first breaking it down into its basic shapes and learning how each section moves and bends in different poses. With time and practice, you will be able to draw believable hands.

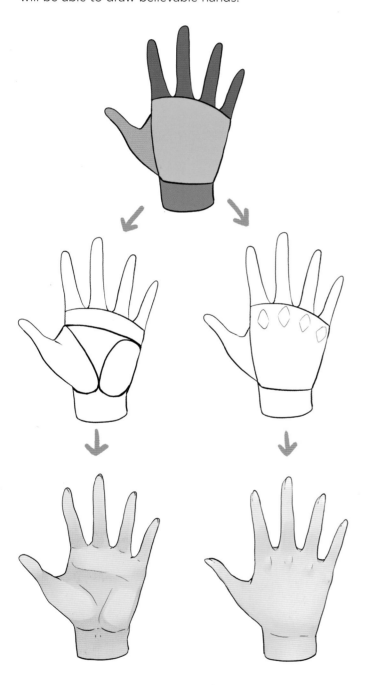

By breaking down the hand in to more manageable sections, it is much easier to visualize it in different positions. Notice that with the same breakdown sketch, you can draw both the front and back sides of the hand. The main sections are fingers, thumb, palm, and wrist.

When drawing fingers, keep in mind that they are cylinders with three distinct joints. Remembering this makes drawing them from the very challenging front-on perspective a little easier. For more hand poses and references, flip to the Templates section starting on page 136.

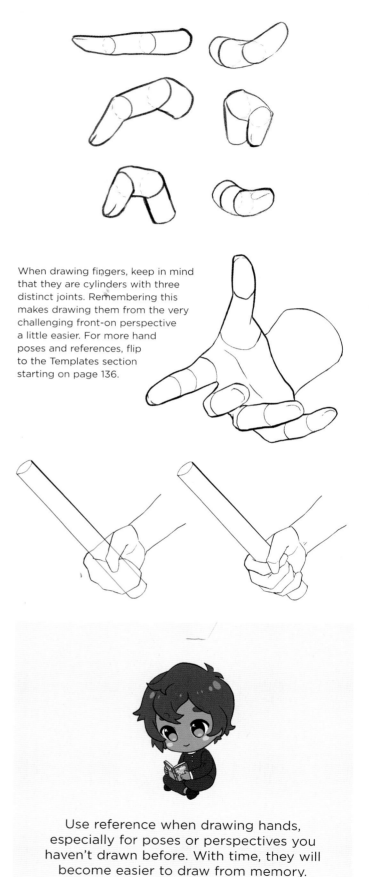

Use reference when drawing hands, especially for poses or perspectives you haven't drawn before. With time, they will become easier to draw from memory.

REALISTIC FEET

Feet, much like hands, are easier to draw when broken down into basic shapes. The four main sections of the feet are the toes, the midsection, the heel, and the ankle and bottom of leg. The toes and ankle can bend the most, whereas the remaining sections have limited movement. Keep this in mind when positioning the foot.

While shoes will typically cover your characters' feet, knowing how to draw feet helps when drawing shoes. For a shoe, first draw the basic foot shape, and then add the specific shoe details over the top.

For shoes that change the foot's position, such as heels, make sure to draw the foot in the proper position before adding the shoe details.

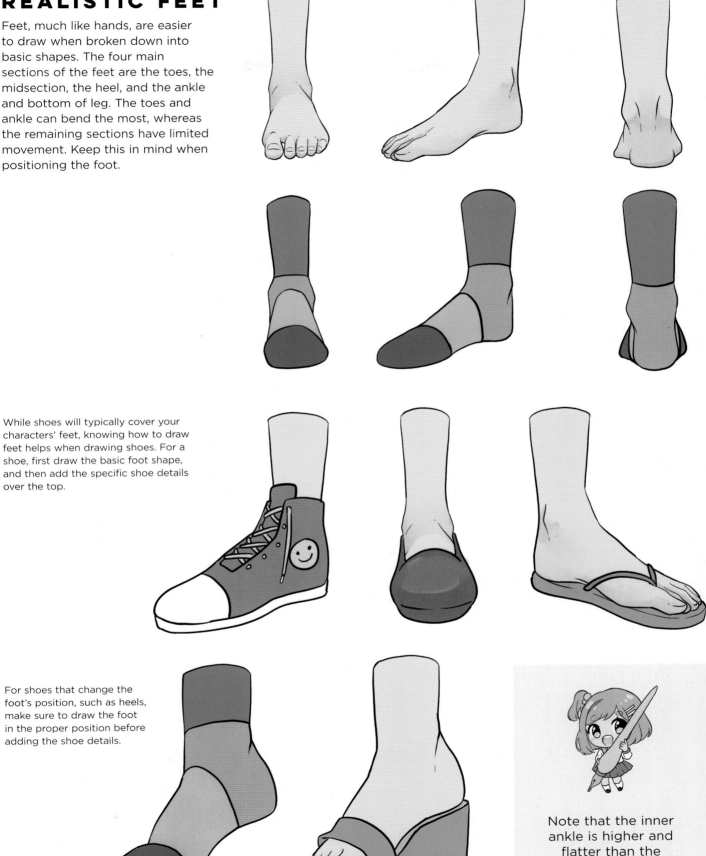

Note that the inner ankle is higher and flatter than the outside ankle.

CHARACTER POSES

Drawing characters in different poses is an extremely fun and exciting part of manga drawing. A pose's foundation starts at the shoulders and hips. Stiff and lifeless poses are ones where the angle of the hips and shoulders are straight and stay parallel to each other. By changing the hips and shoulders, you can instantly create a more interesting and dynamic stance for the character.

DYNAMIC POSES

Something that helps artists avoid the straight and static lines that make a character look stiff is the line of action. The line of action follows a pose, usually the spine of the figure, and evokes movement. Add this to your character drawings by drawing the line of action first and then building the character around it.

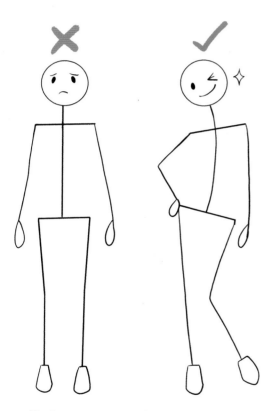

The term *contrapposto* is used in visual arts to describe a figure standing with most of their weight on one foot, which causes the shoulders and hips to tilt at different angles.

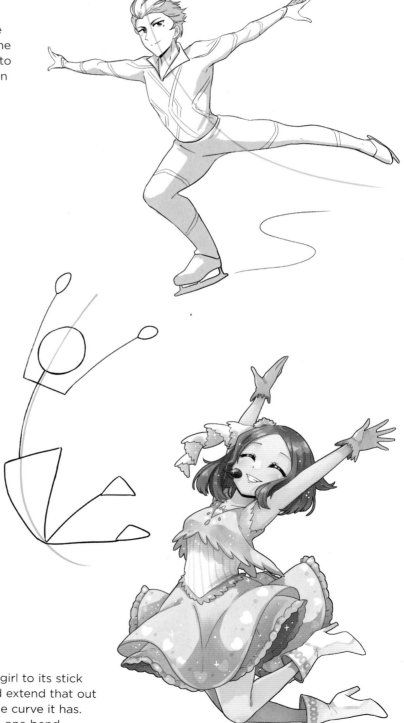

When breaking down this drawing of a jumping idol girl to its stick figure form, we can follow the curve of the spine and extend that out to see this character's line of action. Notice the gentle curve it has. Avoid making these lines too chaotic with more than one bend.

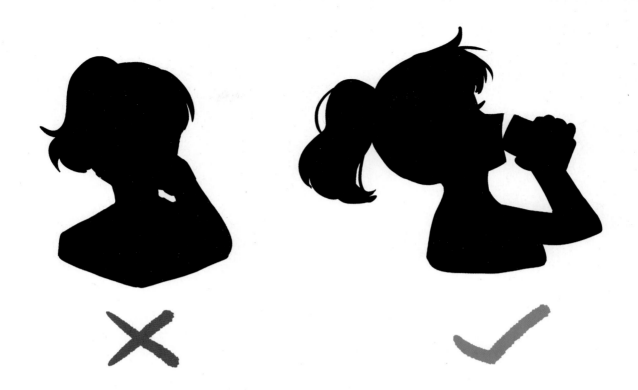

You can also try the silhouette technique where you simply look at the pose's silhouette. Negative space is good and makes a pose more readable. If you can't clearly see what a character is doing by the silhouette, try changing the angle or perspective.

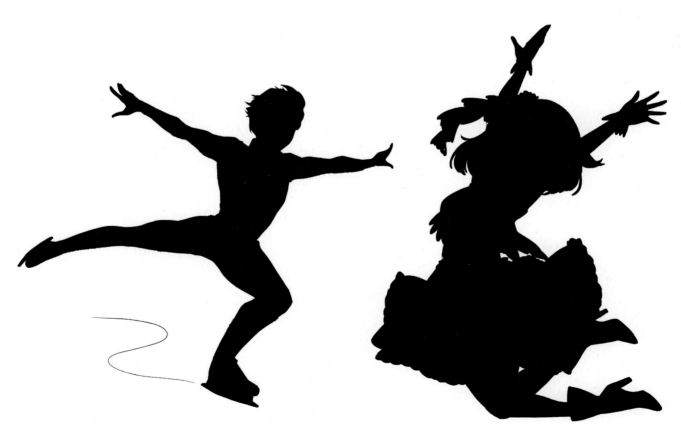

HUGGING

The hug pose focuses on not just one but two people. Hugs can show friendship, love, sadness, forgiveness, and comfort. You may not draw them much in your stories, but a well-timed hug in a manga can express many unsaid emotions between characters. Keep these helpful tips when you draw your next hugging scene.

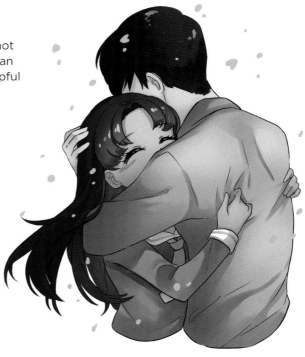

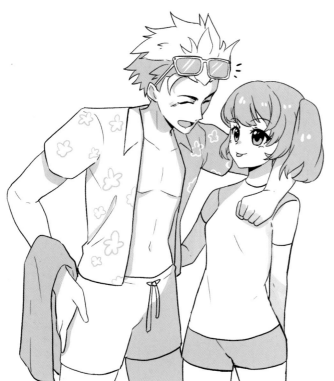

Consider the negative space. The fewer gaps there are between the characters, the more intimate the hug. Are you drawing a friendly hug with space between bodies, or is it a passionate hug with the bodies very close?

Sketch out each body fully, even the parts that overlap. The best way to understand a hug pose is to be able to draw both bodies fully before finalizing the pose. This way, the bodies stay in proportion, and nothing looks off.

Also consider the many different hugs! Whether it's a front hug, back hug, side, or lying-down hug, each can add a different atmosphere to the scene.

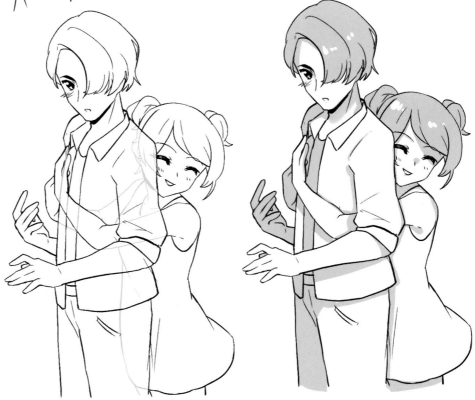

SITTING

With sitting poses, one of the challenges is to understand how the perspective of the legs changes. If you can master how to draw legs at different angles and positions, tackling a sitting pose becomes much easier.

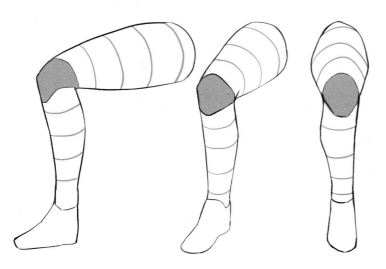

Here are some examples of how a bent leg looks at different perspectives. When drawing your seated character, pay close attention to the legs' position. Are you drawing the legs crossed, bent, or straight? Also consider the surface the character sits on. How they sit on a chair will be different than how they sit on the floor.

The red lines around the legs shown above are called contour lines. Contour lines help artists understand the body's form—its three-dimensional qualities and how it curves. When drawing arms and legs, adding contour lines can help you understand the mass of the body. You will find it especially helpful when drawing clothes.

How a character sits can also indicate something about their personality. Do they take up a lot of room when they sit? If so, that character is probably outgoing or prideful. Introverted and quiet characters sit with their legs and arms close to their bodies.

FIGHTING

To successfully draw characters fighting, you must first have a good understanding of and confidence in drawing the human body. Fight scenes can be challenging, as bodies are drawn in unique poses and perspectives, and usually while a character is mid-movement.

When drawing a fight scene, it's all about balance. The person winning will look more balanced in their stance than the one losing. A balanced pose will either be a character supported on one leg or evenly spread on two legs. A wide space between the feet will make a pose look more balanced. When a character is supported on only one foot, parts of their body must be on either side of that to make the pose look stable and like they won't fall over.

In manga fiction, you can get as creative as you'd like with how characters could fight! The decision to include superpowers is common in action manga stories.

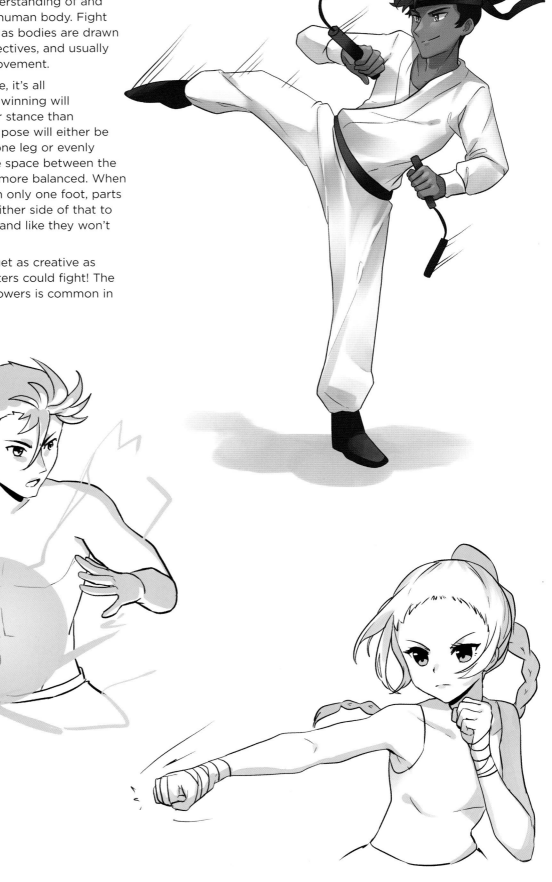

CUTE

Cute poses are both fun and relatively easy to draw. Common ways to make a pose cuter is with winking, sweet smiles, peace signs made with the hands, arms close to the body, or hands close to the face or chest. Cute characters often have larger eyes, representing vulnerability or youth.

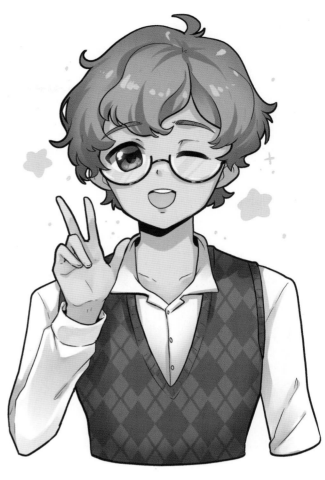

CLOTHING & ACCESSORIES

In this section, Aya and Shun will model five clothing types and genres you will often find in manga. Here you'll also see what elements to think about when drawing them on your own characters.

SCHOOL OUTFIT

One of the most common outfits you will see in manga is a Japanese school uniform. Aya is wearing what is known as a *seifuku*, or "sailor suit," a type of school uniform for girls. They have a distinctive collar paired with a bow or tie. Skirts vary in length, depending on the season. Round-toed leather shoes are often the footwear of choice.

Shun is wearing a common male uniform called a gakuran. These are mostly seen in middle school, whereas blazers become the uniform of choice in high school. Gakuran are made in either black or navy blue and have their iconic stand-up collar.

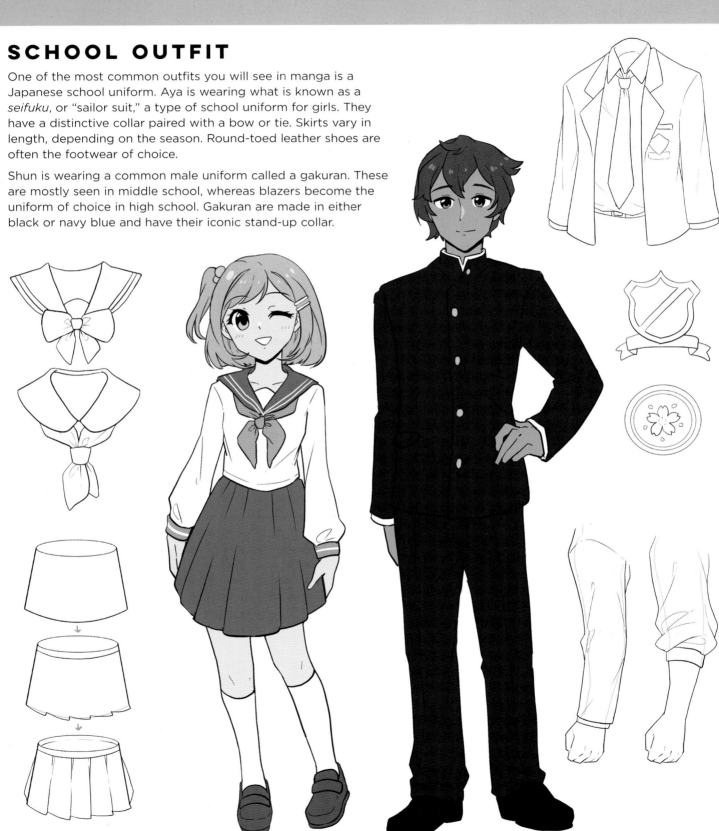

TRADITIONAL JAPANESE KIMONO

Kimonos are a cultural garment worn in Japan for a variety of occasions such as festivals, weddings, and funerals. The more casual form of this is the *yukata*, which can be worn around the house and is popular in casual settings and summer festivals. Make sure to always draw the kimono and yukata wrapping left over right. It is only ever wrapped the opposite way when burying the dead.

Aya is wearing the traditional kimono accessorized with an *obi* (the large sash around the waist), *obiage* (sash on the top of the obi), *obijime* (the string tied around the obi), and *obidome* (an accessory passed through the obijime). The socks are special socks called tabi. Aya also is holding a traditional Japanese fan, a common accessory with kimonos.

Shun is wearing the more casual yukata with a thinner obi wrapped around his waist. He is also holding a bag called a kinchaku, which holds small personal items such as phones and are used when wearing a kimono or yukata. When wearing a yukata, tabi socks are not worn.

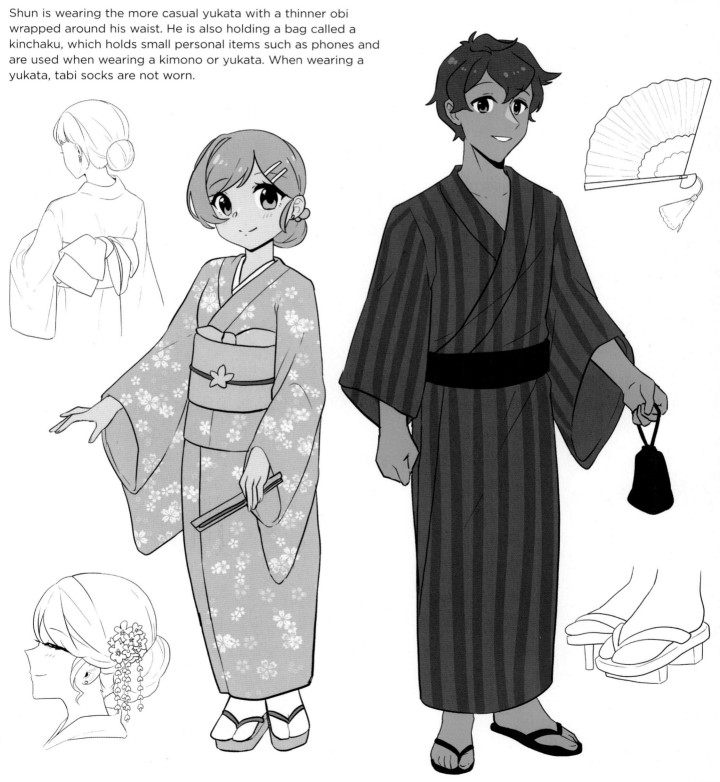

FANTASY OR MAGICAL OUTFIT

The fantastical characters in fantasy and magical stories need equally fantastical outfits, but with such creative possibilities, it can be difficult to choose what to include to make a character look the part!

For the magical girl look, Aya is wearing a sparkly dress with an iconic large bow on her chest. Ruffles, frills, and balloon sleeves are all the rage with magical girl uniforms, so don't hold back. These garments aren't for practicality but for beauty. Include a large staff or wand to enhance the magical qualities of this character.

Shun is wearing a fantasy outfit which, similar to Aya's, isn't about practicality. Layering and cutaways create fun and unique clothing that belongs a fantasy world. Horns, pointed ears and fingertips, unnaturally colored hair, and excessively long hair all add to the fantasy character vibe.

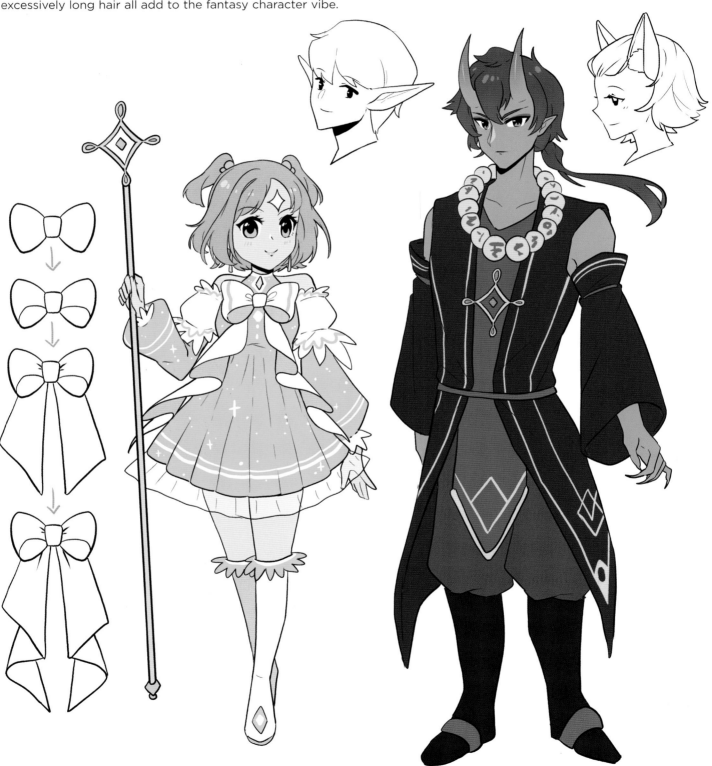

FUTURISTIC OUTFIT

Who knows what the future holds? Manga stories that are based in the future can vary greatly, but they usually fall into one of two overarching themes: utopian and dystopian. Here are two futuristic examples, and you can see how their dress implies these different types.

In Aya's future, the world and aesthetic are clean, ordered, and full of advanced technology. Her appearance is neat, simple, and includes high-tech accessories to emphasize the futuristic setting.

Shun, however, comes from a possibly dystopian future. His world is scrappy, hardworking, and machine based. These themes are visible in his clothing, with the dark color palette and his mechanical arm seemingly made from different scrap metal pieces. The robot, which may be a friend or foe, also seems to be made of scrap metal. These design choices lead us to believe he lives in a harder and more risky future than Aya.

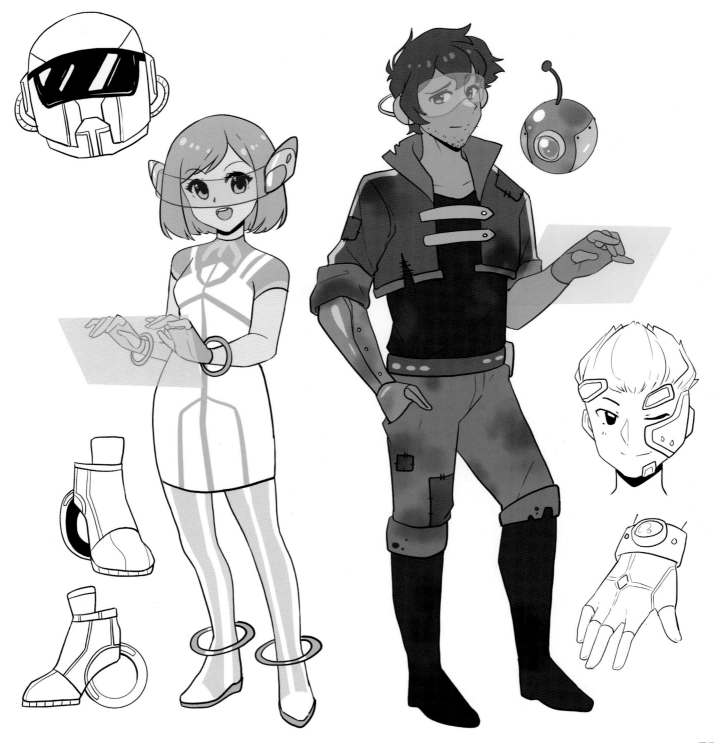

SPORTY OUTFIT

Sports uniforms, usually designed for practicality, vary greatly between each sport. Design uniforms to have striking colors and team symbols, if appropriate, and don't forget to include any safety gear that's needed.

Aya is a tennis lover and as such wears the classic white tennis dress and sneakers. As tennis is a solo or duo sport, there are no team names or symbols to add to her uniform.

Shun is a basketball player, signified by his jersey, loose shorts, and basketball shoes. He is also wearing a knee brace, which may indicate an old injury.

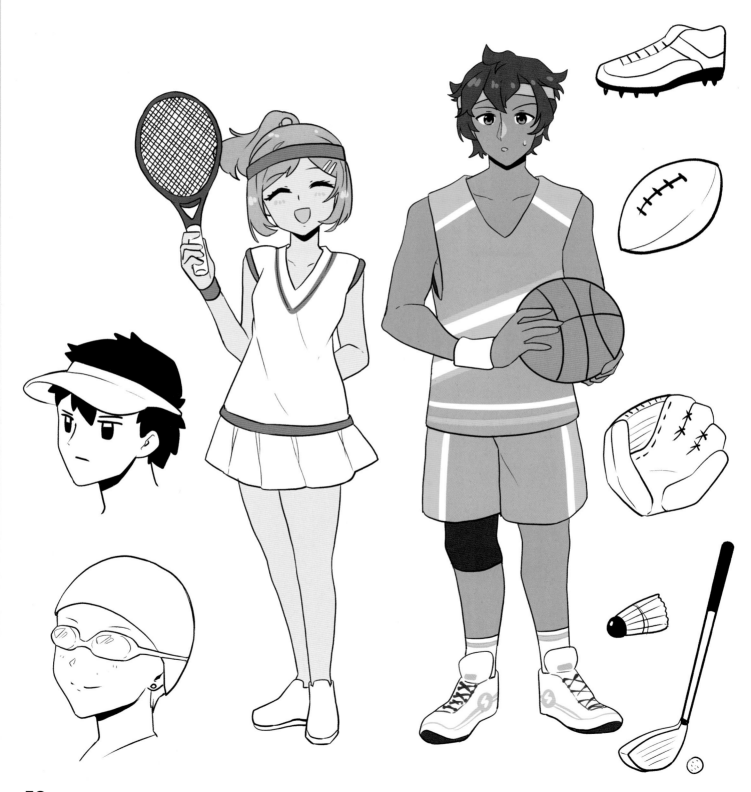

COMMON ACCESSORIES

One of the most fun parts of designing outfits for manga characters is the option to accessorize! If you're stuck on what to possibly include to jazz up any outfit, here are some options.

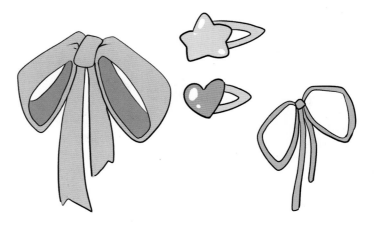

Hair accessories and bows quickly add a feminine touch to any hairstyle. Bows are also a great addition to feminize an outfit in a simple and quick way.

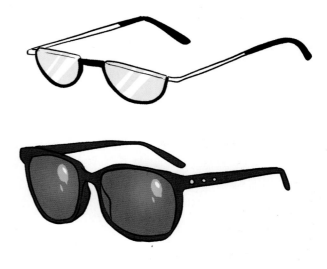

Jewelry can elevate many outfits from casual to elegant. They can also signify a character's wealth and social status.

Glasses, both reading glasses and sunglasses, are an accessory that can emphasize parts of a character's personality. Bookish characters often wear reading glasses, and cool, mature, or popular characters often wear sunglasses, but this isn't always the case.

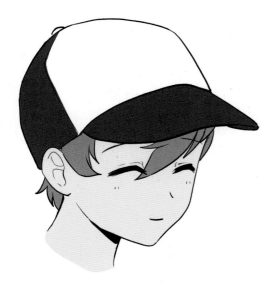

Hats are often practical, such as a beanie to stay warm or sun hat to stay cool. Hats are also worn for different uniforms, so make sure to research those specific designs as needed. They can also be a quirky addition to an outfit to accent a character's personal style.

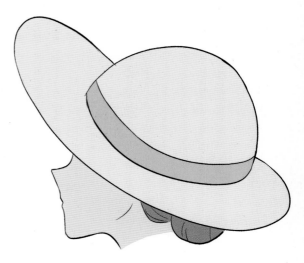

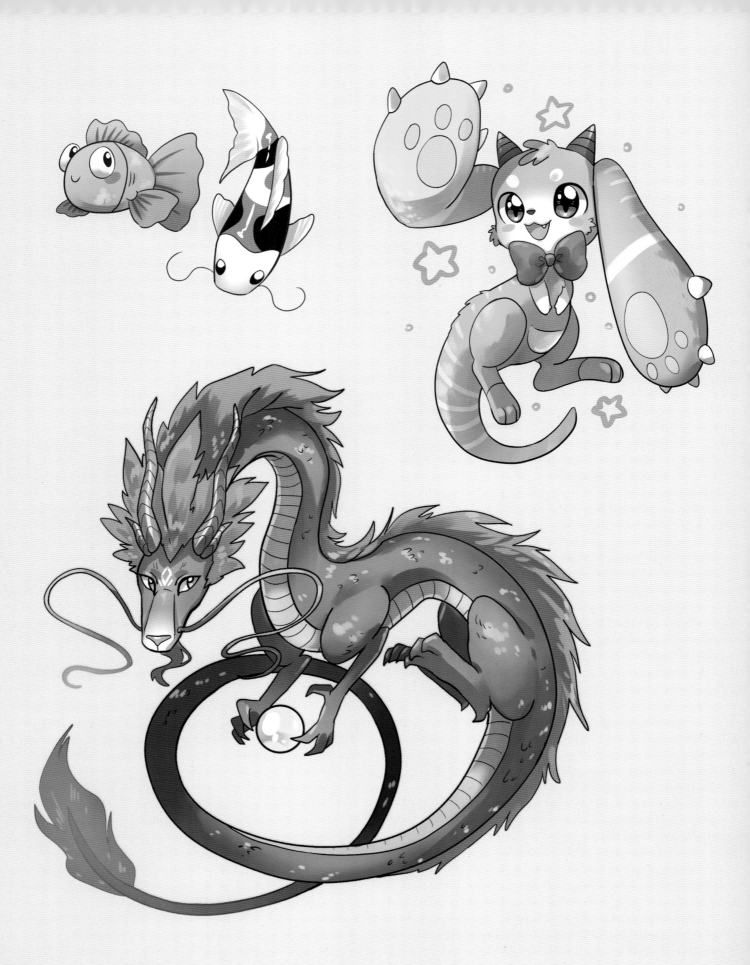

Chapter 4

CREATURES

PETS

Cats, dogs, birds, and fish will often appear in manga because many of us spend our lives with these companions. The more unique pets, which follow these popular ones in this section, are great to include in your manga to personalize it and stand out from the rest.

CAT

Cats are nimble and agile, which is reflected in their flexible and slender bodies.

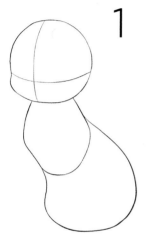

Start by drawing three rounded shapes: one for the head, one for the upper body, and one for the hips.

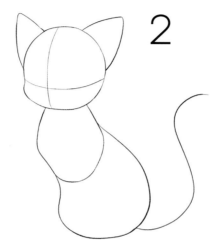

Add ears to the head and a guide for the tail.

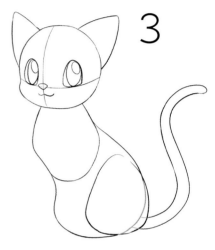

Fill out the tail and draw another oval on the hips for the thighs. Add the facial features of eyes, nose, and mouth.

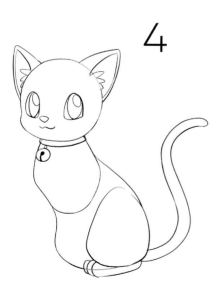

Draw the back feet under the thigh oval. Add a collar around the neck and details in the ears.

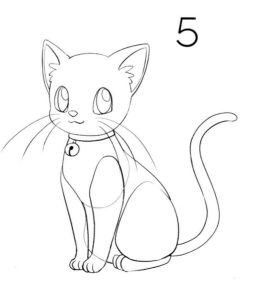

Place the front legs and paws, which extend from the upper body. Also add whiskers.

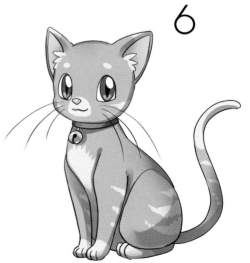

Outline in black liner pen, erase the guidelines, and add color.

DOG

Dogs come in many shapes in sizes, so adjust these steps as needed depending on the breed.

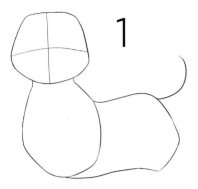

Start by drawing the three main rounded shapes: one for the head, one for the upper body, and one for the hips. Also add the guide for the tail.

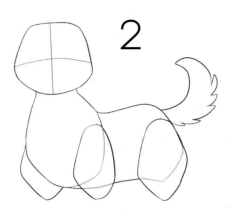

Bulk out the tail and add rounded diamond shapes in the front and rear for the upper legs.

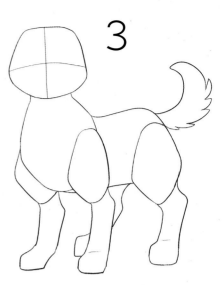

Extend the legs down from each diamond. Depending on the age and breed, dogs' paws can be quite large.

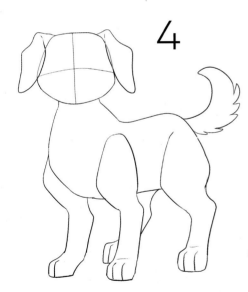

Add ears onto each side of the head and detail the paws.

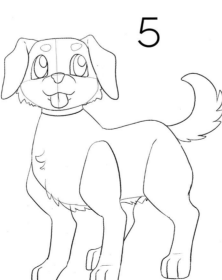

Draw in the face and add fur. Common areas of longer fur are on the chest, belly, and tail. If desired, add a collar around the neck.

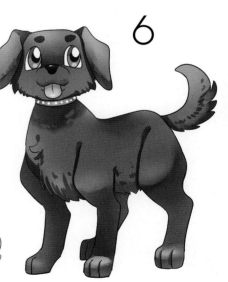

Outline in black liner pen, erase the guidelines, and color the dog. If you are drawing a specific breed, use reference so you can accurately depict the colors and patterns.

BIRD

Birds of all shapes and sizes may appear in your manga! Here is how to draw a super cute little bird.

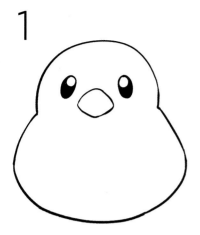

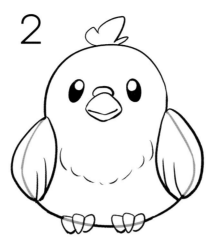

Start with an egglike shape that bulges at the bottom. Draw in small eyes and a beak.

Add in wings on either side and little feet at the bottom. Include a tuft of feathers on the head and chest and the area of the nostrils above the beak.

Outline in black liner pen, erase guidelines, and add color. Many pet birds have bright and bold colors.

FISH

Here are two common types of fish seen as pets in manga, the goldfish and the koi fish.

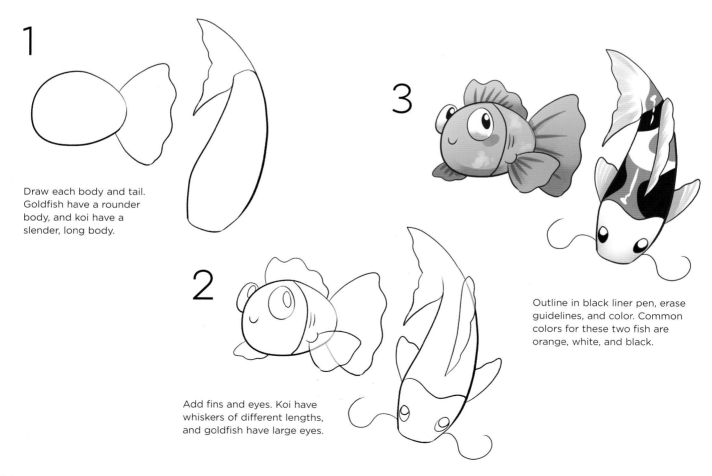

Draw each body and tail. Goldfish have a rounder body, and koi have a slender, long body.

Add fins and eyes. Koi have whiskers of different lengths, and goldfish have large eyes.

Outline in black liner pen, erase guidelines, and color. Common colors for these two fish are orange, white, and black.

LIZARD

Lizards are great little pets to have. They can be super cute and packed with personality.

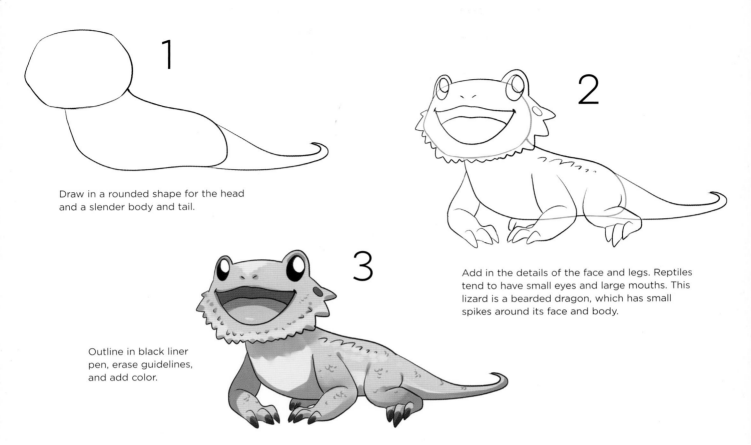

Draw in a rounded shape for the head and a slender body and tail.

Add in the details of the face and legs. Reptiles tend to have small eyes and large mouths. This lizard is a bearded dragon, which has small spikes around its face and body.

Outline in black liner pen, erase guidelines, and add color.

MOUSE

This adorable little mouse can become a different kind of small rodent by changing the ears and tail.

 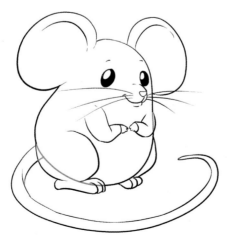 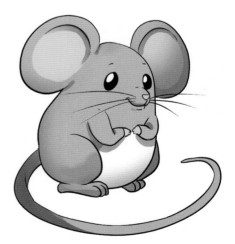

Draw a potato shape for the body. Then attach large ears to the top of the shape and a tail to the bottom.

Add in the face, arms, and legs. The legs are much larger than the arms. Mice also have long whiskers.

Outline in black liner pen, erase guidelines, and color in your mouse.

MAGICAL CREATURES

In this section, you will learn to draw some magical creatures and spirits. In Japan, spirits such as the kitsune and tanuki are called yokai, and they are popular characters in manga. Two additional fantasy creatures, a dragon and a mermaid, are also included in this section.

KITSUNE

Kitsune are mischievous and smart fox spirits, commonly depicted as humans with fox features. Their tail number ranges from one to nine, depending on the kitsune's age and maturity. You may see a kitsune surrounded by small blue fireballs. These are *onibi*, which are a type of "ghost light" in Japanese legends.

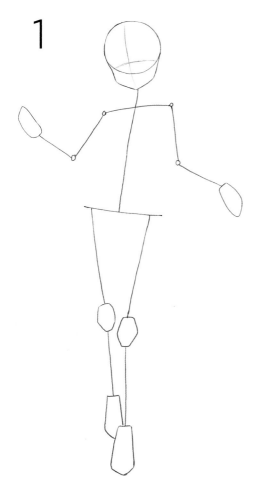

Start by drawing the head, leaving enough room to draw the body below. Use the head height to determine the proportions for the rest of the stick-figure body. Draw the torso two heads tall, and make the legs the length of three heads. Keep the hands and feet simple for now, drawing them as basic shapes.

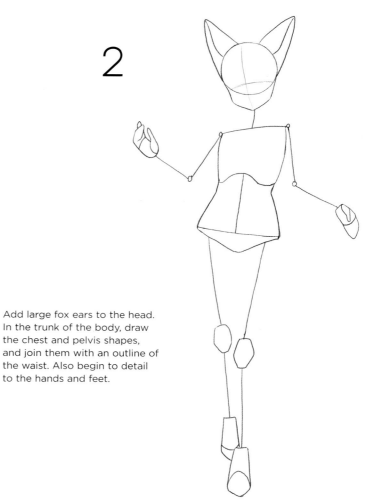

Add large fox ears to the head. In the trunk of the body, draw the chest and pelvis shapes, and join them with an outline of the waist. Also begin to detail to the hands and feet.

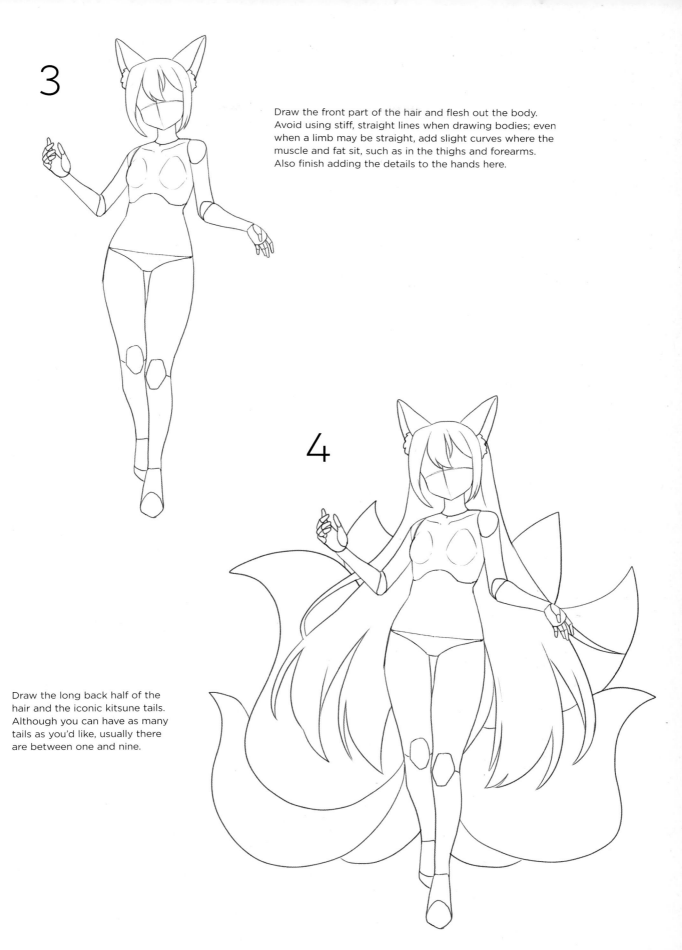

3

Draw the front part of the hair and flesh out the body. Avoid using stiff, straight lines when drawing bodies; even when a limb may be straight, add slight curves where the muscle and fat sit, such as in the thighs and forearms. Also finish adding the details to the hands here.

4

Draw the long back half of the hair and the iconic kitsune tails. Although you can have as many tails as you'd like, usually there are between one and nine.

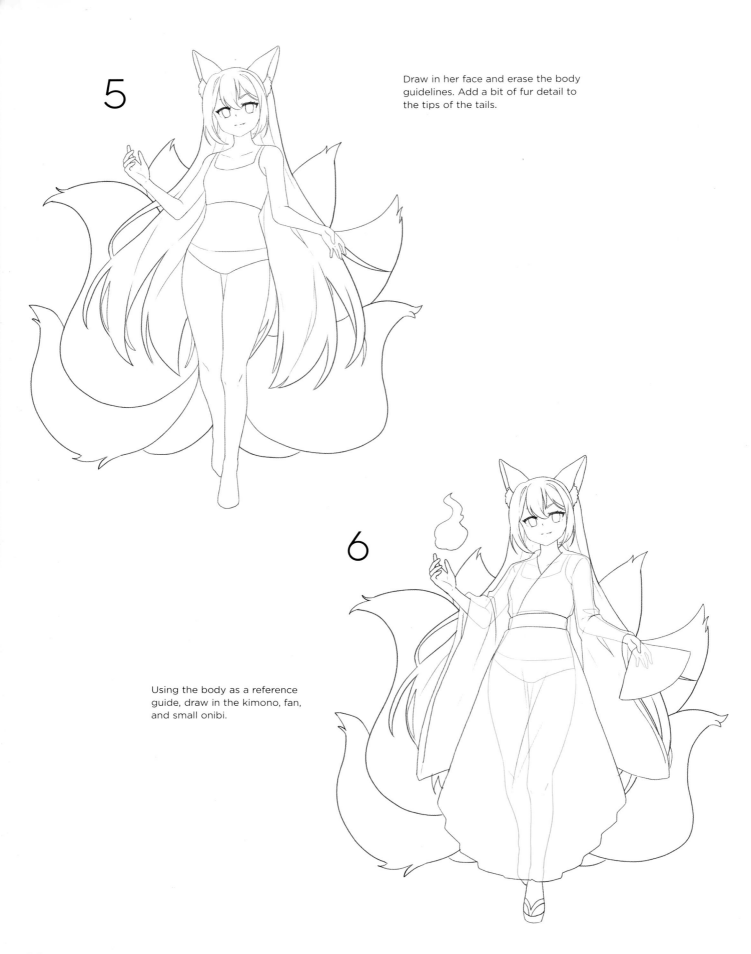

5

Draw in her face and erase the body guidelines. Add a bit of fur detail to the tips of the tails.

6

Using the body as a reference guide, draw in the kimono, fan, and small onibi.

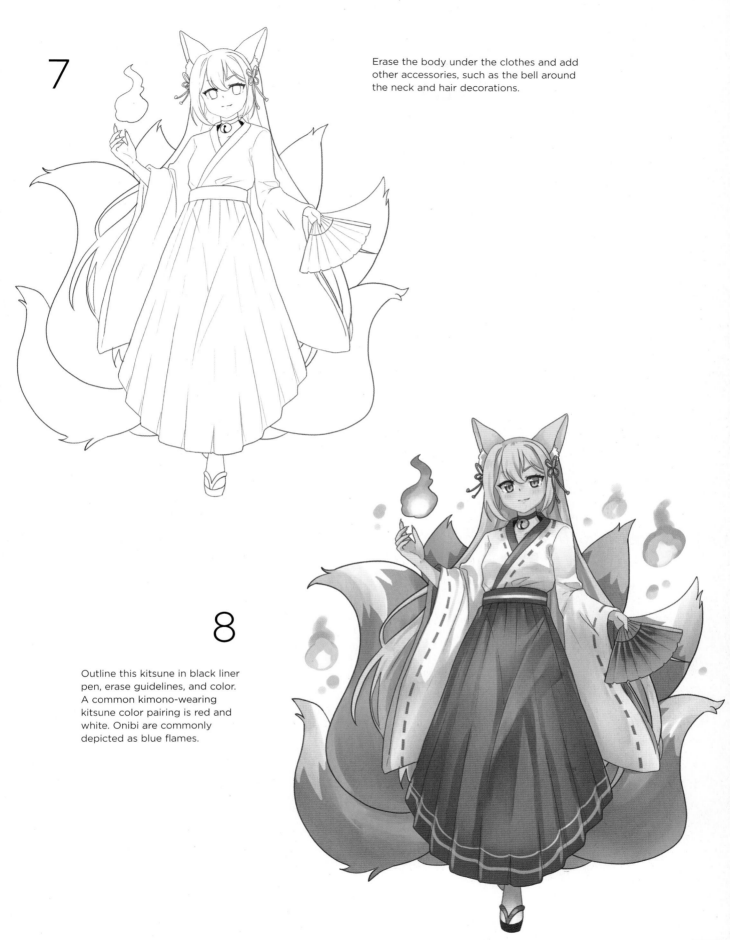

7

Erase the body under the clothes and add other accessories, such as the bell around the neck and hair decorations.

8

Outline this kitsune in black liner pen, erase guidelines, and color. A common kimono-wearing kitsune color pairing is red and white. Onibi are commonly depicted as blue flames.

TANUKI

The tanuki yokai are joyous and mischievous shape-shifting spirits. They resemble a Japanese raccoon dog, which is also known locally as a tanuki. They sometimes have a leaf on their head that adds to their powers of metamorphosis. They can walk and talk like humans and are sometimes dressed in traditional Japanese garments.

1

Start by drawing the head and the body shapes, which resemble a rounded pentagon-shaped head atop an egg-shaped body.

2

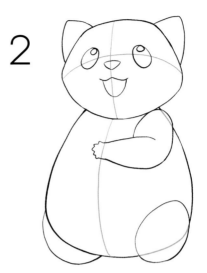

Along the face guidelines, place the eyes, nose, and mouth. Tanuki are cheeky and mischievous, so add a smiling mouth with large eyes. Place small triangle ears on the head, draw in the left arm, and add the thighs on the base of the body. Note that the paws of tanuki are small compared to their arms and legs.

3

This tanuki is busy getting food, so draw an apple in the paw. Add two thin lower legs from the thighs and smaller triangles in the ears.

4

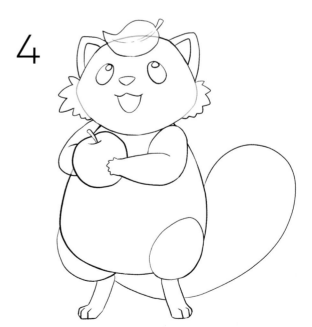

Draw a large leaf on the head and small tufts of fur on both cheeks. Draw the other arm coming around to hold onto the apple, but note that the paw is obscured. Add two small lines on each foot for the toes. The tail sits behind, extending from the base of the body. A tanuki's tail is thin near the body and then grows thicker and rounds off at the end.

5

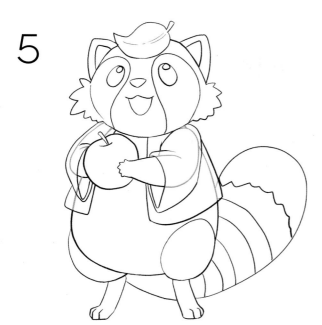

Draw the tanuki wearing a *haori*, a light jacket usually worn over a kimono. Make sure the haori has its iconic large sleeves. Draw markings around the eyes and on the tail that resemble those found on a Japanese raccoon dog.

6

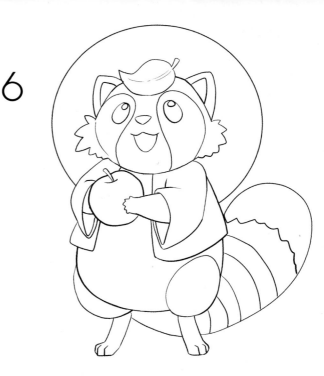

Draw a large circle behind the head to create a hat known as a kasa.

7

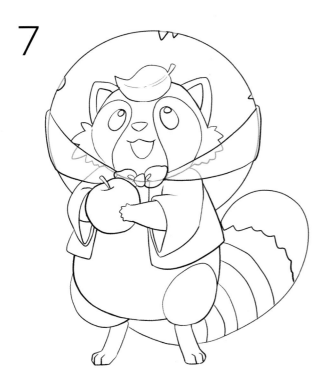

Add a sash around the neck to hold the kasa in place. To add weathering on the hat, draw little triangular notches that break its perfect circular shape.

8

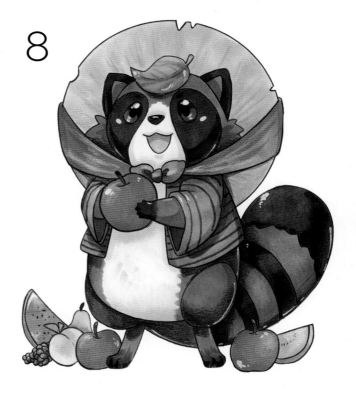

For finishing touches, add all the fruit the tanuki has gathered at the feet, outline everything in black liner pen, erase guidelines, and color! This illustration is an example of traditional coloring on paper with markers.

DRAGON

The mythological dragon is mentioned in folklore from almost every continent and varies greatly in appearance by each region. A more traditionally Asian dragon, which is seen commonly in fantasy manga, tends to have these specific features: long and slender bodies, no wings, horns, hair that starts at the head and stretches to the tail, and short legs with large claws.

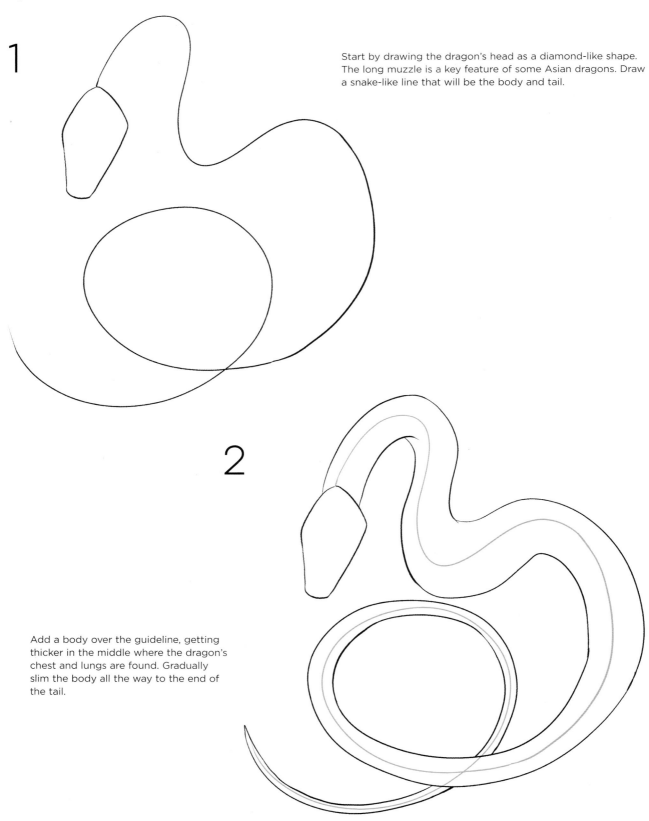

1

Start by drawing the dragon's head as a diamond-like shape. The long muzzle is a key feature of some Asian dragons. Draw a snake-like line that will be the body and tail.

2

Add a body over the guideline, getting thicker in the middle where the dragon's chest and lungs are found. Gradually slim the body all the way to the end of the tail.

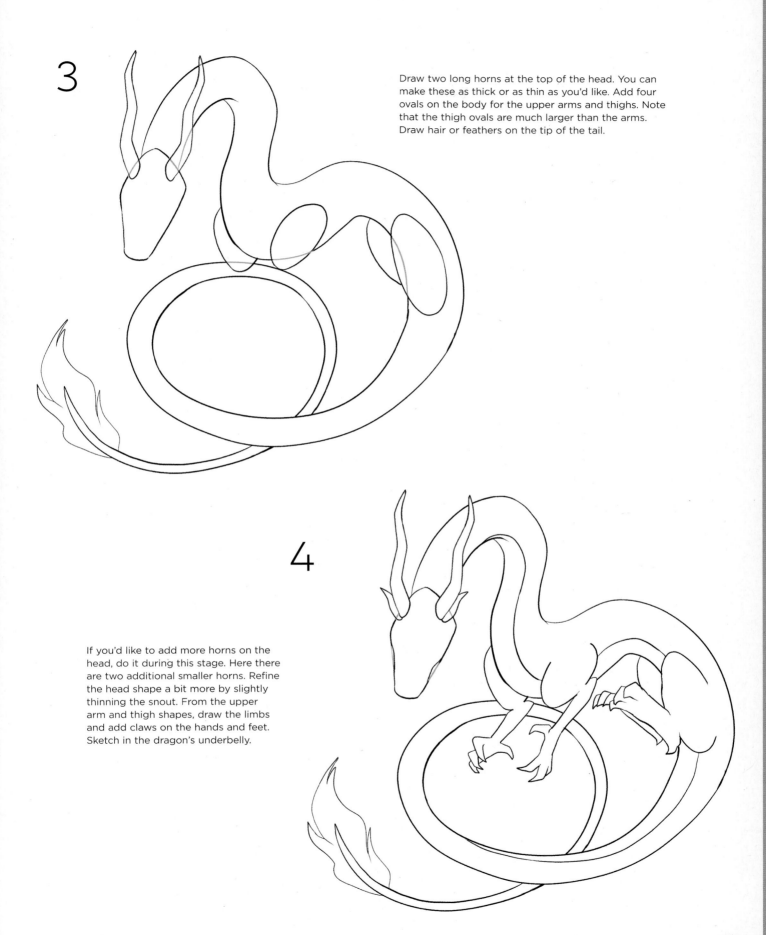

3

Draw two long horns at the top of the head. You can make these as thick or as thin as you'd like. Add four ovals on the body for the upper arms and thighs. Note that the thigh ovals are much larger than the arms. Draw hair or feathers on the tip of the tail.

4

If you'd like to add more horns on the head, do it during this stage. Here there are two additional smaller horns. Refine the head shape a bit more by slightly thinning the snout. From the upper arm and thigh shapes, draw the limbs and add claws on the hands and feet. Sketch in the dragon's underbelly.

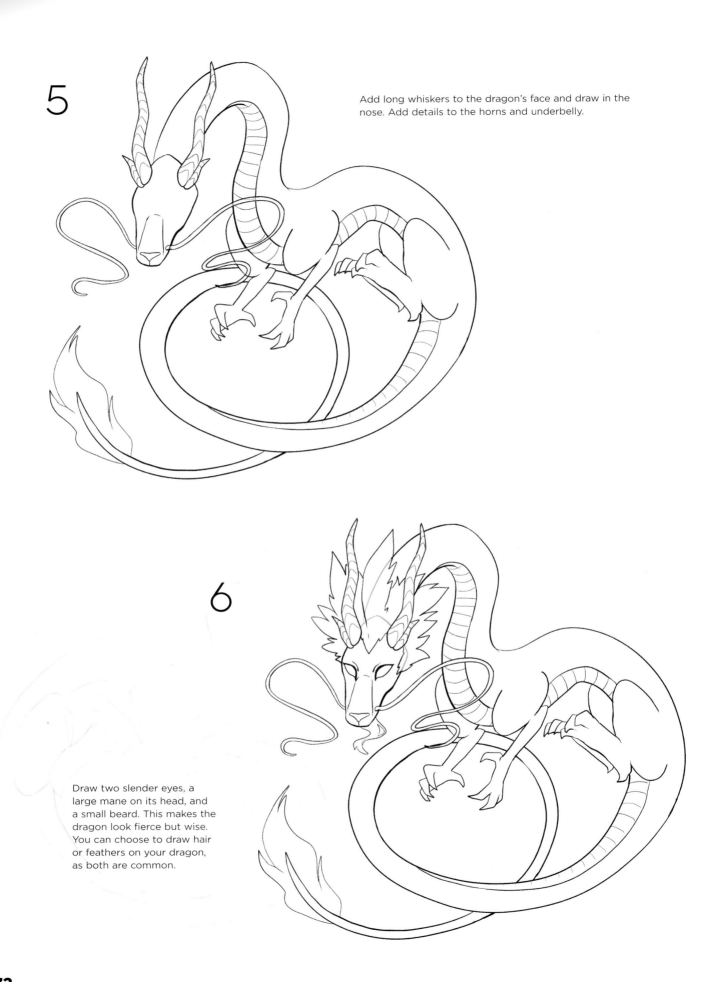

5

Add long whiskers to the dragon's face and draw in the nose. Add details to the horns and underbelly.

6

Draw two slender eyes, a large mane on its head, and a small beard. This makes the dragon look fierce but wise. You can choose to draw hair or feathers on your dragon, as both are common.

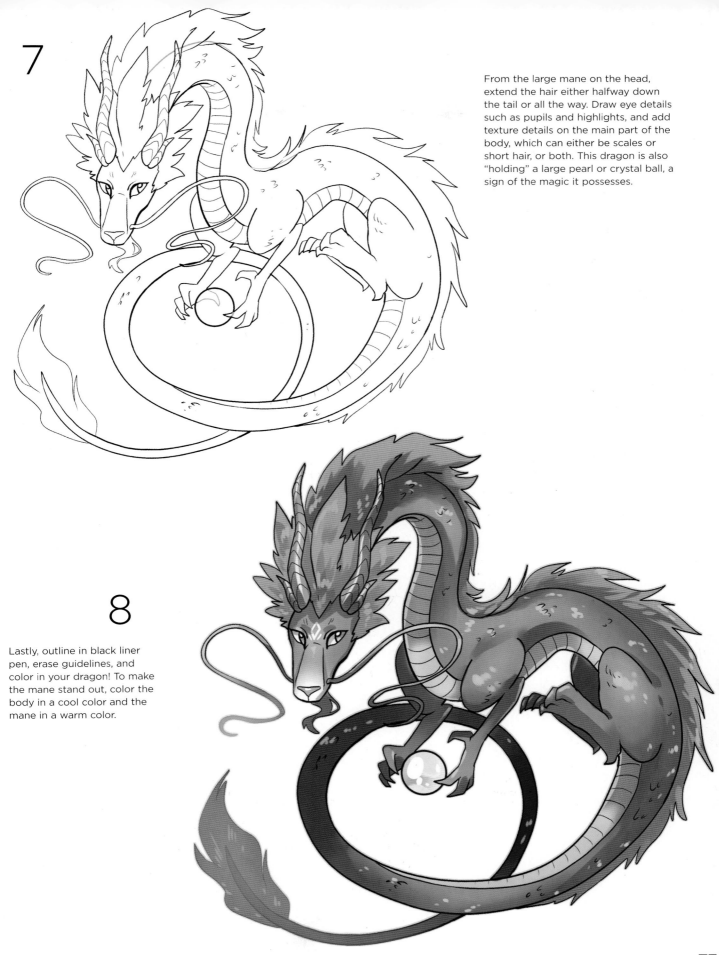

7

From the large mane on the head, extend the hair either halfway down the tail or all the way. Draw eye details such as pupils and highlights, and add texture details on the main part of the body, which can either be scales or short hair, or both. This dragon is also "holding" a large pearl or crystal ball, a sign of the magic it possesses.

8

Lastly, outline in black liner pen, erase guidelines, and color in your dragon! To make the mane stand out, color the body in a cool color and the mane in a warm color.

MERMAID

In Japan, a yokai similar to a mermaid is called a ningyo, which is much more fish than human. In this drawing, we will marry both ideas by taking a mermaid design and adding more fishlike ningyo elements to her.

1

Begin as you would when drawing any person. Sketch the guidelines for the head, shoulders, arms, and trunk of the body. At the hips, instead of drawing two leg guides, continue the line, imagining it as a tail that can be as long and as flexible as you'd like.

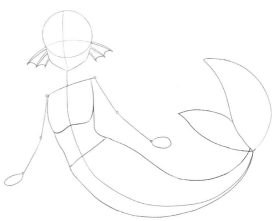

2

Following the middle horizontal guideline on the head, extend it out and create three evenly spaced bones that will become fins where the ears would normally sit on a person. Draw the chest as a rounded box in the body's top half. At the end of the tail, draw two large fins.

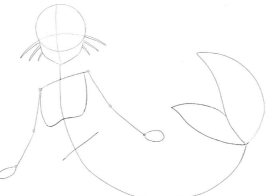

3

Connect the chest to the hips by drawing the waist. Follow that line down as the body becomes the tail and have it taper to the tail fins. On the head, add small, curved lines to connect the bones to create small fins.

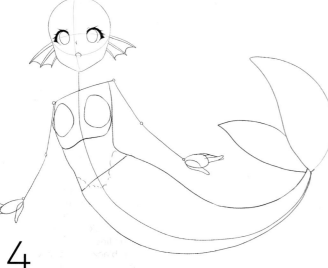

4

Draw in the eyes, nose, and mouth. Add basic anatomy details to the hands and chest. Where the hips sit, lightly sketch in a "V" shape where the fish scales start on the tail.

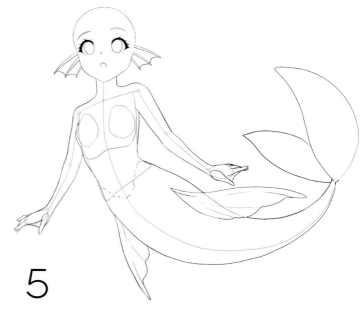

5

Now properly draw in the top half of the body with the neck, arms, and torso. For an optional addition, draw two more decorative fins on the tail, keeping the lines fluid to give a sense of the mermaid floating in the water. On her hands, connect each finger with a curved line to show webbed fingers, which help her swim.

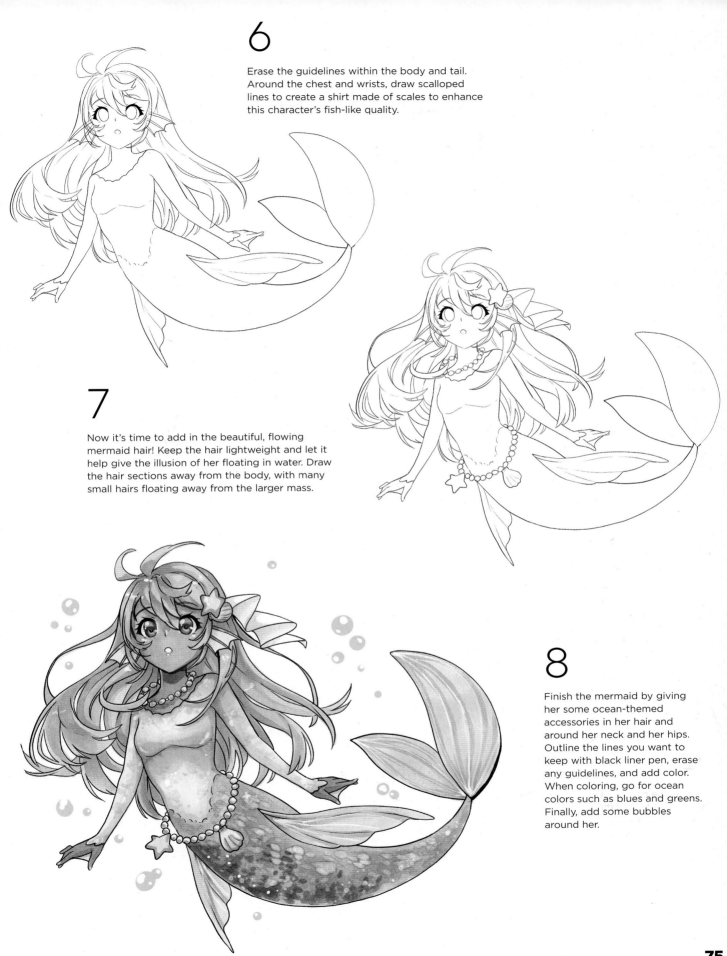

6

Erase the guidelines within the body and tail. Around the chest and wrists, draw scalloped lines to create a shirt made of scales to enhance this character's fish-like quality.

7

Now it's time to add in the beautiful, flowing mermaid hair! Keep the hair lightweight and let it help give the illusion of her floating in water. Draw the hair sections away from the body, with many small hairs floating away from the larger mass.

8

Finish the mermaid by giving her some ocean-themed accessories in her hair and around her neck and her hips. Outline the lines you want to keep with black liner pen, erase any guidelines, and add color. When coloring, go for ocean colors such as blues and greens. Finally, add some bubbles around her.

MASCOTS

Animal-like mascots or partners are a fun and sometimes critical addition to many stories. They can be there for comedic relief or as a cute friend, but more often than not they help lead and support the hero on their quest with their special knowledge or quirky abilities.

MASCOT TYPES

When designing a mascot for your story, remember that they can usually be filed into one of three categories: cute, comedic, or cool. Each tends to have a different purpose, but like any manga rule, these can be changed if the mangaka chooses.

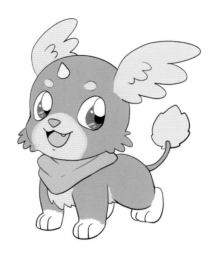

Cute mascots usually follow baby-like proportions and have large heads and eyes paired with small bodies. This type of mascot isn't usually very powerful but does help support the hero and helps them in other ways. Their classic cuteness makes them an easy character to love and want to protect.

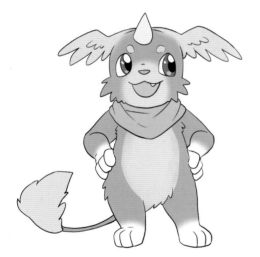

Comedic mascots help but often annoy the protagonist. They are witty with a strong personality. This is matched in their design by giving the mascot human-like proportions and poses. They will walk on two feet and talk and act like a person. Their main support in story, besides their humor, lies in their intelligence.

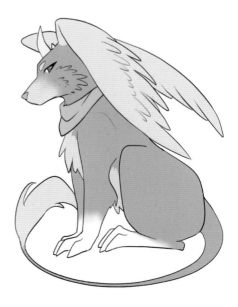

Cool mascots are less common but are full of majesty and power. They are much more beastly and intimidating than cute or comedic mascots. Sometimes a cute or comedic mascot may transform into a cool mascot in the protagonist's time of need by some magical force. The wings and horn on this design look more functional than the last two designs, and its facial expression is much more serious.

MASCOT DESIGN INSPIRATION

The best way to begin designing a mascot is to base it off an animal that already exists. Then by adding different animal features, you can turn it into a new fantasy creature for your story. Here are some different fur, foot, ear, wing, and horn types you could add to your mascot.

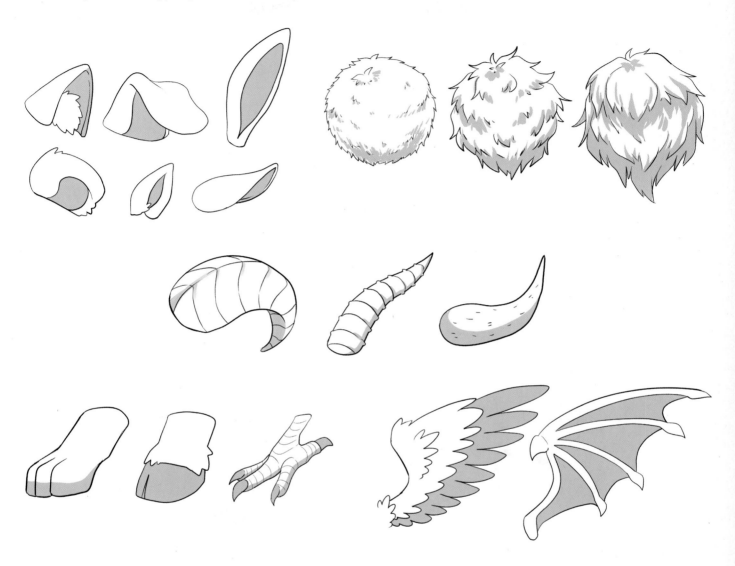

If you have no idea where to start, try this fun exercise to create a random mascot! Go to the emoji keyboard on any smart device and navigate to the animal section. Close your eyes and click anywhere to get an animal for the base. Then go to the food section. Close your eyes and click to get a food that will be the new color palette for the animal. Lastly, go to objects and do the same thing to find a unique random thing the mascot is good at or to get a design theme idea. For example, if I got a giraffe, broccoli, and a telescope, I would design a green giraffe that loves the stars or who has a star-themed outfit. This exercise can inspire some creations you'd never think of!

MASCOT

This mascot is based loosely on a rabbit and kangaroo, but it uses its ears like arms.

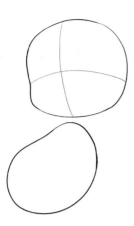

1

Draw in the head as a rounded square-like shape. The body will be roughly the same size as the head but more egg-shaped. Make sure both shapes are not touching.

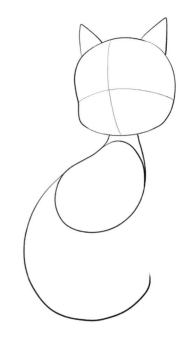

2

Add two triangles on the head, which will become small horns. Connect the head and body shapes with a little neck. From the left side of the body, extend a line down and curve it around. This will become the tail.

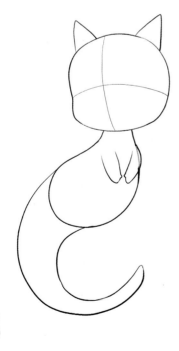

3

Draw the remaining side of the tail and connect it to the body. At the top, near the neck, draw two little arms. These aren't the mascot's main arms, so you don't need to add many details.

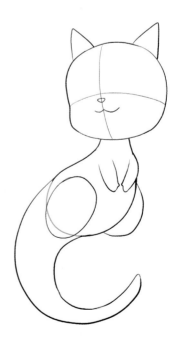

4

At the base of the body, add two ovals for the large kangaroo-like thighs. On the vertical head guideline, draw a small and catlike nose and mouth.

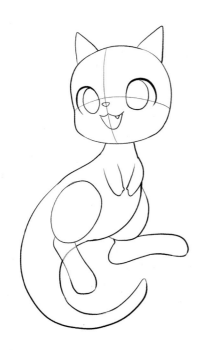

5

Finish off the facial features with two large eyes and extend the mouth to be open with a small tooth off to one side. From the thighs, draw in two long, rounded rectangles for the big feet.

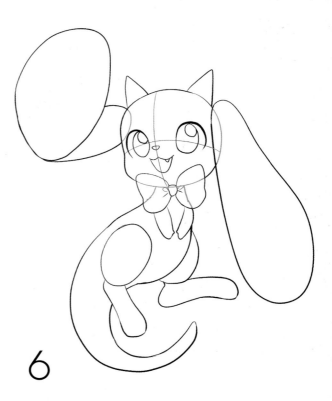

6

Time to add in the overly large ears! One falls to the side of the body while the other is positioned at a right angle. Add small circular highlights to the eyes and a big bow tie around its neck as a fun accessory.

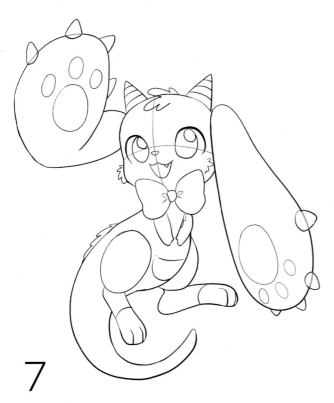

7

Now draw the remaining small details, which include hair tufts on the head and body, paw pad designs on the ears with little claws at the end, a small pouch on the belly, and details around the feet and horns.

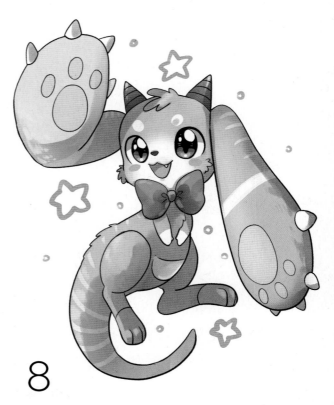

8

Outline in black liner pen, erase guidelines, and color! Because mascots are usually fantasy creatures, be as creative with the colors as you want!

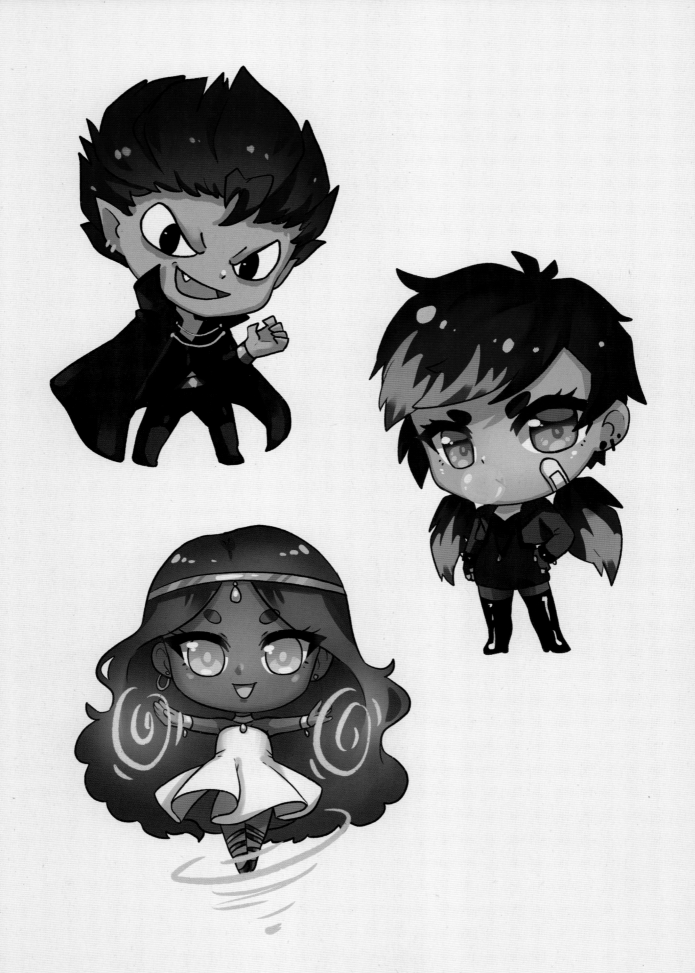

COMMON HERO TYPES

There are four common hero types found in manga. If you know which category your protagonist falls into, it may help you better design and write for this character.

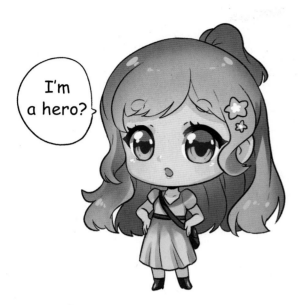

The everyday hero type does not have any extraordinary qualities, but these characters are forced into situations and events that cause them to become a hero in one way or another. Whether or not they embrace this role, these underdogs usually have a strong moral compass that leads them to do the heroic deeds the story calls for.

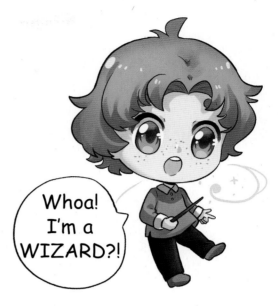

The classic hero is one of the most common types we see. A seemingly normal person discovers or is bestowed powers and talents that allow them to accomplish heroic and amazing feats.

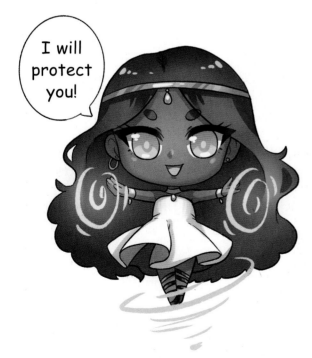

An epic hero is an otherworldly, godlike being from legend that is all-powerful, usually with some sort of noble birthright that leads them on their journey.

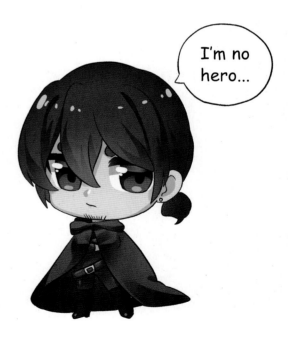

An anti-hero works in the gray area between good and evil. These characters tend to pursue their goals in risky, selfish, or dishonest ways. Sometimes this character type will push past their villainous qualities and eventually embrace the good-guy hero ideals.

HERO: KIRA MOON

The hero Kira Moon is based off the moonstone gemstone, and you can see elements of the stone reflected in her design. Kira Moon draws power from the moon and shares it with the people on Earth through moonstone crystals. Her scarf creates portals, which she uses when she needs to fight off enemies around the universe who want to harm Earth, including her own brother Kaze. These instructions will take you through the digital coloring process, but you can color using any medium you prefer.

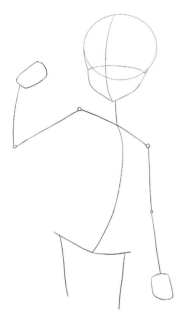

1

Begin by drawing the basic head guidelines and stick figure skeleton. Only draw a small portion of the legs, as this will be a thigh-up drawing. Make sure to draw the gentle curve in the spine. Position one arm up and one down, as she will eventually be holding a staff.

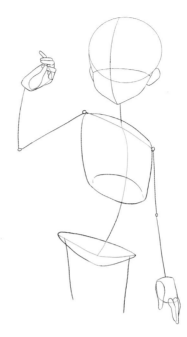

2

Draw in the upper torso and the pelvic bone as a rectangle and a triangle. Add ears and details to the hands.

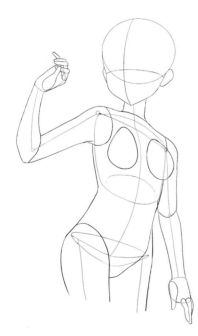

3

Flesh out the stick figure, following the guidelines and perspective. She will be wearing a dress, so you don't need to add a lot of detail to the lower half of the body.

4

Add the facial features and the front half of the hair. Erase the stick figure skeleton guidelines.

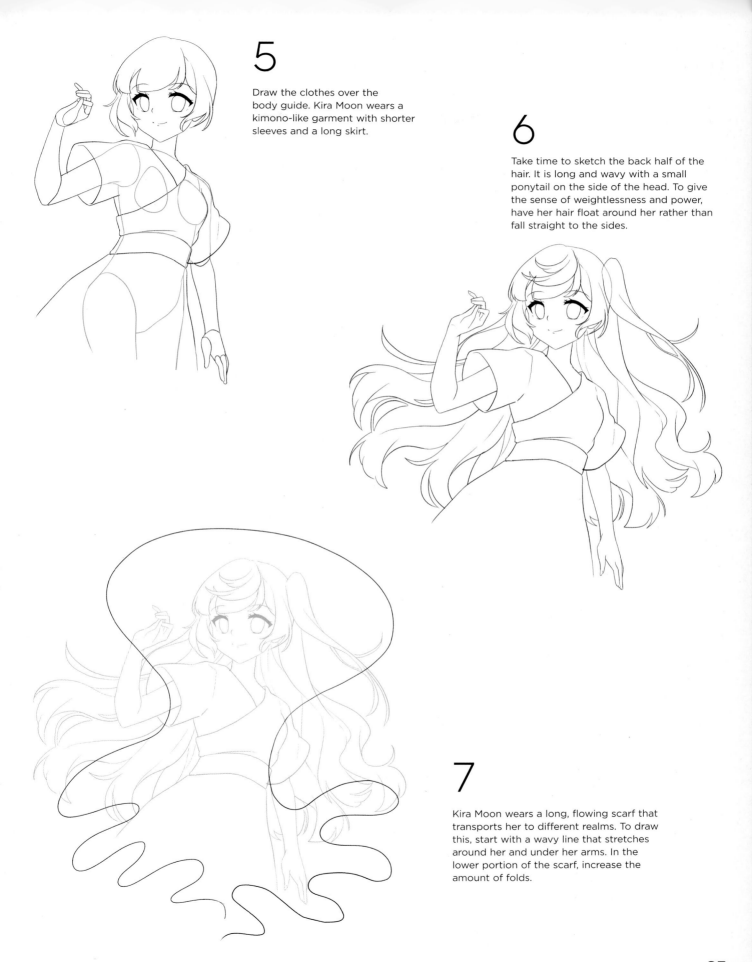

5

Draw the clothes over the body guide. Kira Moon wears a kimono-like garment with shorter sleeves and a long skirt.

6

Take time to sketch the back half of the hair. It is long and wavy with a small ponytail on the side of the head. To give the sense of weightlessness and power, have her hair float around her rather than fall straight to the sides.

7

Kira Moon wears a long, flowing scarf that transports her to different realms. To draw this, start with a wavy line that stretches around her and under her arms. In the lower portion of the scarf, increase the amount of folds.

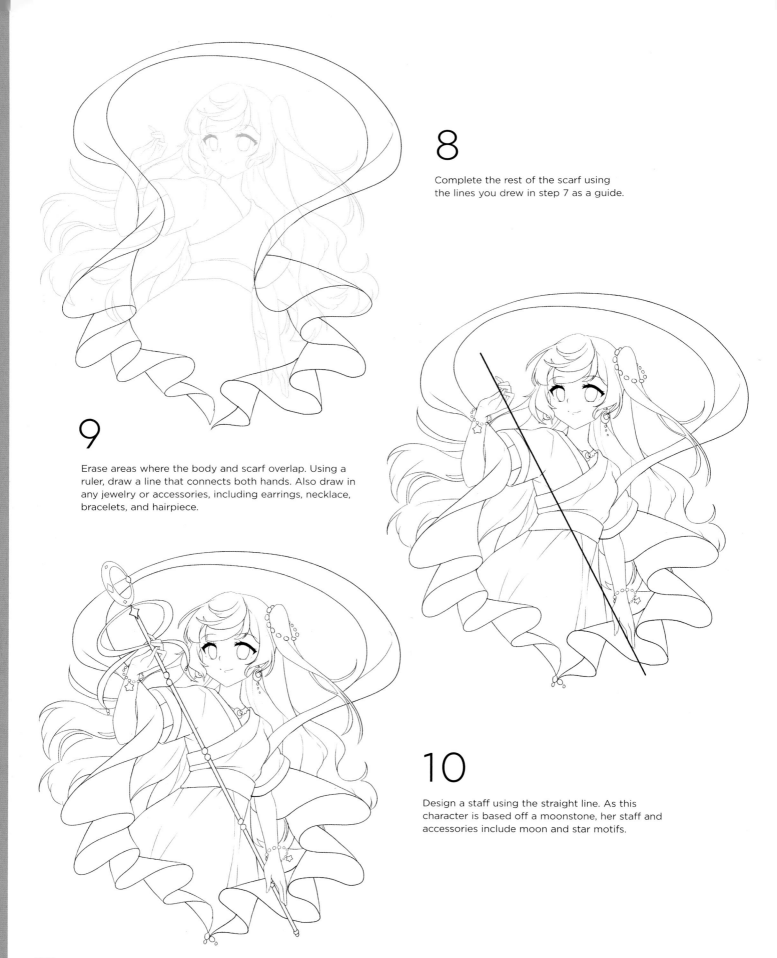

8

Complete the rest of the scarf using the lines you drew in step 7 as a guide.

9

Erase areas where the body and scarf overlap. Using a ruler, draw a line that connects both hands. Also draw in any jewelry or accessories, including earrings, necklace, bracelets, and hairpiece.

10

Design a staff using the straight line. As this character is based off a moonstone, her staff and accessories include moon and star motifs.

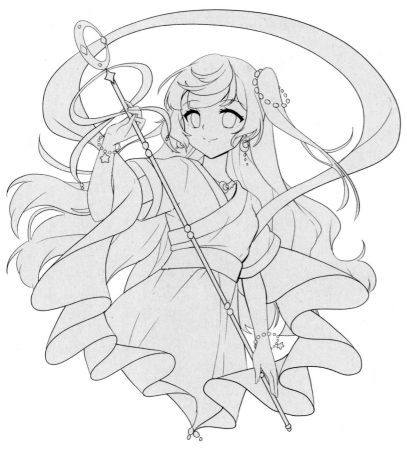

11

Complete the line art with a black pen if you are drawing traditionally. Erase any remaining guidelines and add color! If you'd like, follow the grayscale digital coloring method shown here, which is one way to color art digitally. Start by filling the areas to color in with a light gray. This will provide even shadows across the entire piece.

12

Using two to three different darker grays, add the shadows. Put these shadows in a new layer placed on top of the base gray layer, preferably in a "clipping" layer.

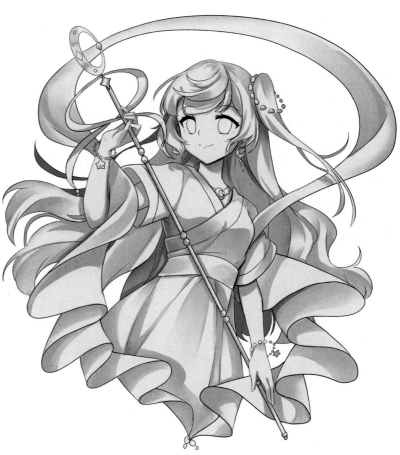

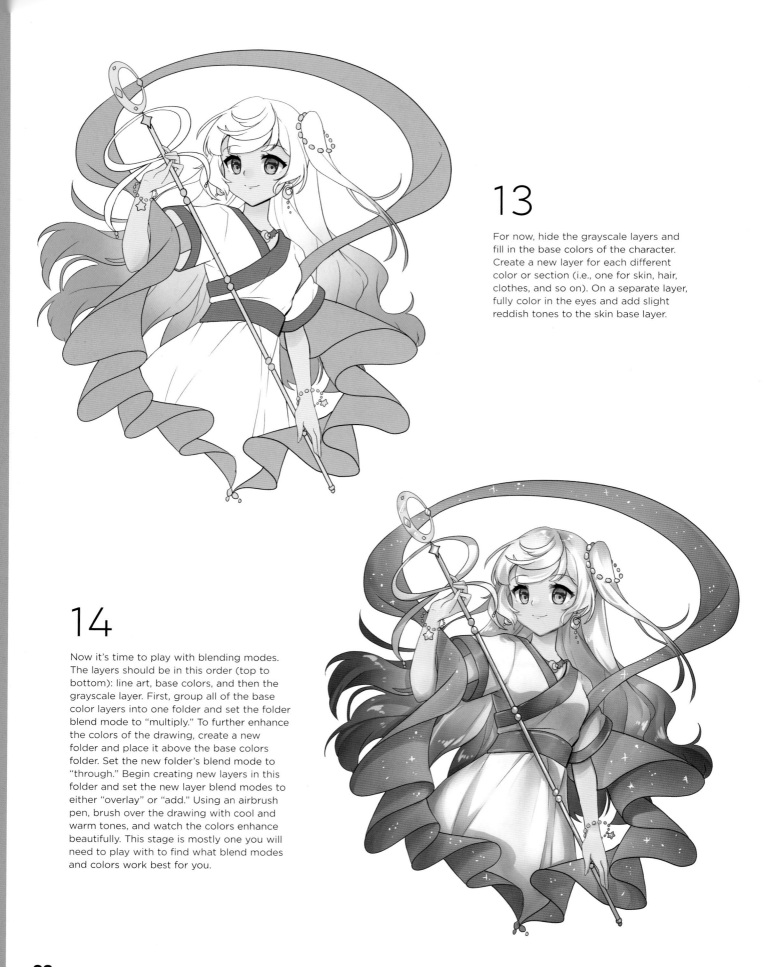

13

For now, hide the grayscale layers and fill in the base colors of the character. Create a new layer for each different color or section (i.e., one for skin, hair, clothes, and so on). On a separate layer, fully color in the eyes and add slight reddish tones to the skin base layer.

14

Now it's time to play with blending modes. The layers should be in this order (top to bottom): line art, base colors, and then the grayscale layer. First, group all of the base color layers into one folder and set the folder blend mode to "multiply." To further enhance the colors of the drawing, create a new folder and place it above the base colors folder. Set the new folder's blend mode to "through." Begin creating new layers in this folder and set the new layer blend modes to either "overlay" or "add." Using an airbrush pen, brush over the drawing with cool and warm tones, and watch the colors enhance beautifully. This stage is mostly one you will need to play with to find what blend modes and colors work best for you.

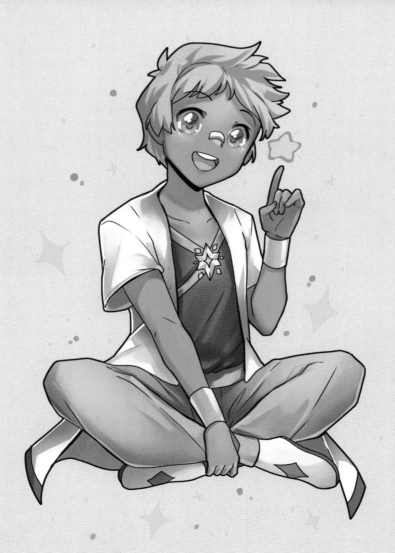

Chapter 5

CHARACTER DEVELOPMENT

HEROES

The hero or protagonist is the main character of your story and the character you want your audience to be rooting for the most. In addition to making your main character's personality memorable, remember that your hero should also visually stand out. Main characters in manga often have uniquely colored and styled hair, which makes them memorable and conspicuous in crowded scenes.

THE HERO FORMULA

There is a secret formula to creating a good hero that people will remember, and that is to give them flaws and weaknesses, an interesting backstory, and to develop their character throughout your story.

Flaws & Weaknesses make characters believable and interesting. When designing a protagonist, you may be tempted to make them perfect in every way, hoping that will make the audience love them, but this has the opposite effect, as those reading can't relate to this perfect person. Instead, give your hero flaws and weakness, some they may want to overcome during their journey and some they will naturally keep throughout the storyline. These flaws and weaknesses should stem from a solid and believable backstory.

A backstory is the story of a character up until the point where the reader meets them at the beginning of the book. You won't write 10 pages of backstory before you start in on the main story; instead, include information about the character's life throughout the book when it makes sense. Backstory elements included in the book should explain why a character thinks or acts a certain way. For example, if your main character has trust issues, their backstory will explain why they became that way. This gives the character more believability and relatability, both things that help a reader bond with a protagonist. With this background, we can throw our hero into a story that will result in the best character development.

Character development is the satisfying resolution at the end where characters have matured through the trials they have experienced during the story. A character with trust issues at the beginning of a story may have to trust others throughout their journey. In the end they come to realize there are people in their life they can rely on, and they live a happier and more fulfilled life than they would have if the events they experienced in the story had never happened.

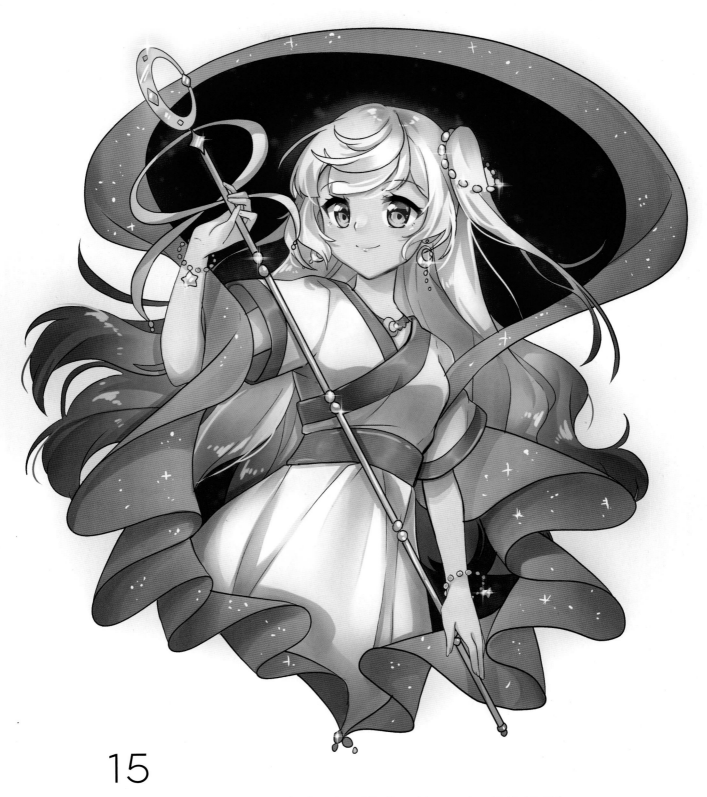

15

To finish off this drawing, add some details on top of the line art layer, such as highlights and stray hairs around the head. Also, within the scarf, fill the background layer with a dark navy to add a sense of magic and connection with space or travel. Add any other highlights or glows that you want, and then your hero will be all done!

VILLAINS

When developing a villain, think about the character's motives, as well as their relationship to the hero of your story. For motive, decide why they do what they do and what made them a villain. Having a believable and understandable motive for your villain helps in your manga story planning and character building. Now enters your hero. Examine the relationship between the two characters. Is their rivalry personal or situational? Are they friends turned to enemies, or maybe enemies who eventually turn into friends? Interesting dynamics between the hero and villain will keep readers invested in your manga story.

COMMON VILLAIN TYPES

Just as heroes have different archetypes they tend to follow, so do villains. Here are some of the more popular ones seen in manga stories.

An arch nemesis is a character whose goals, morals, or motive go directly against the hero's.

The spurned character experiences a strong negative emotion after being rejected by someone they love and channels their energies in the wrong direction.

The rival has the same goal as the hero and will do anything to beat them.

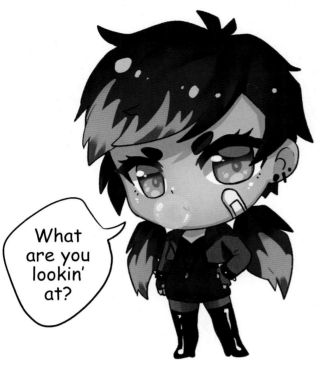

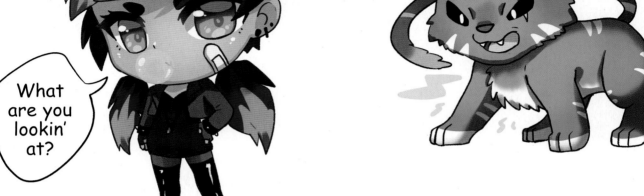

The bully has a backstory that explains their decisions in a way that the reader can understand, relate to, and sympathize with the character.

The machine or beast is a fantasy character, often a monster or self-aware machine. Their motives are based on instincts rather than morals.

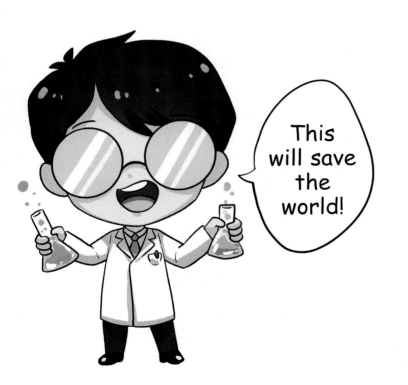

The anti-villain may have justifiable reasons (in their minds, at least) for their evil actions. Their motivations and goals may be good, but their execution is cruel or dangerous.

The pure evil villain is driven by no other reason than to be evil. Their motives and goals have no justification but to create chaos and destruction. This is a less popular choice in villains, but when used in the right story, it can be a worthy foe for your hero to face.

VILLAIN: KAZE MOON

Our hero was the light side of the moon. Now we introduce the dark side! Villainous Kaze Moon is the rival brother of Kira Moon. He can turn into shadow and manipulate shadows to do his bidding.

1

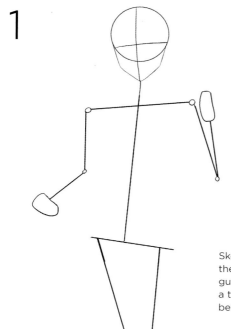

Sketch the head and the stick figure body guide. This piece will be a thigh-up view, so stop before the knee.

2

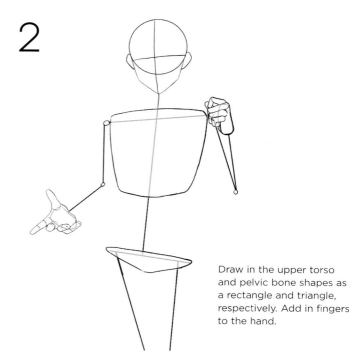

Draw in the upper torso and pelvic bone shapes as a rectangle and triangle, respectively. Add in fingers to the hand.

3

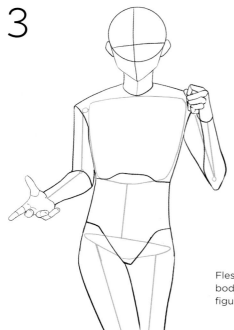

Flesh out the rest of the body, following the stick figure guide.

4

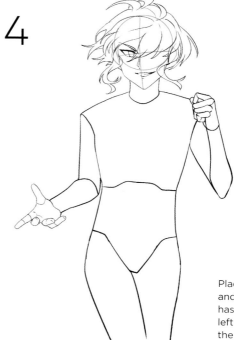

Place the facial features and detail the hair. Kaze has an eye patch on his left eye, so only draw the right eye.

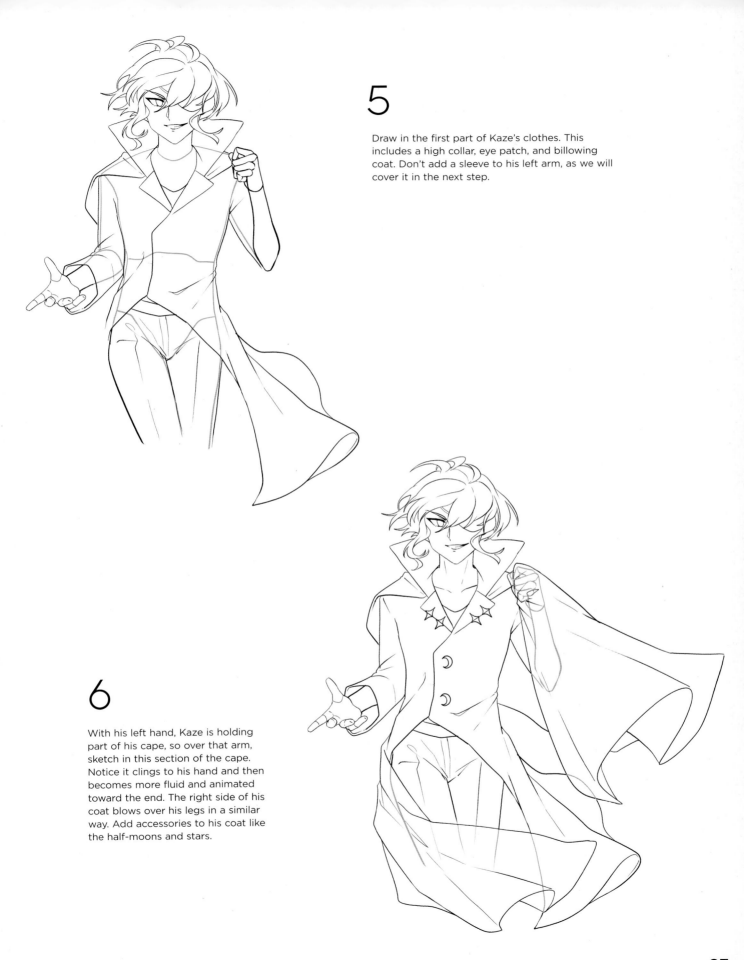

5

Draw in the first part of Kaze's clothes. This includes a high collar, eye patch, and billowing coat. Don't add a sleeve to his left arm, as we will cover it in the next step.

6

With his left hand, Kaze is holding part of his cape, so over that arm, sketch in this section of the cape. Notice it clings to his hand and then becomes more fluid and animated toward the end. The right side of his coat blows over his legs in a similar way. Add accessories to his coat like the half-moons and stars.

7

Now line with a fine-liner pen and erase the sketch to prepare for coloring.

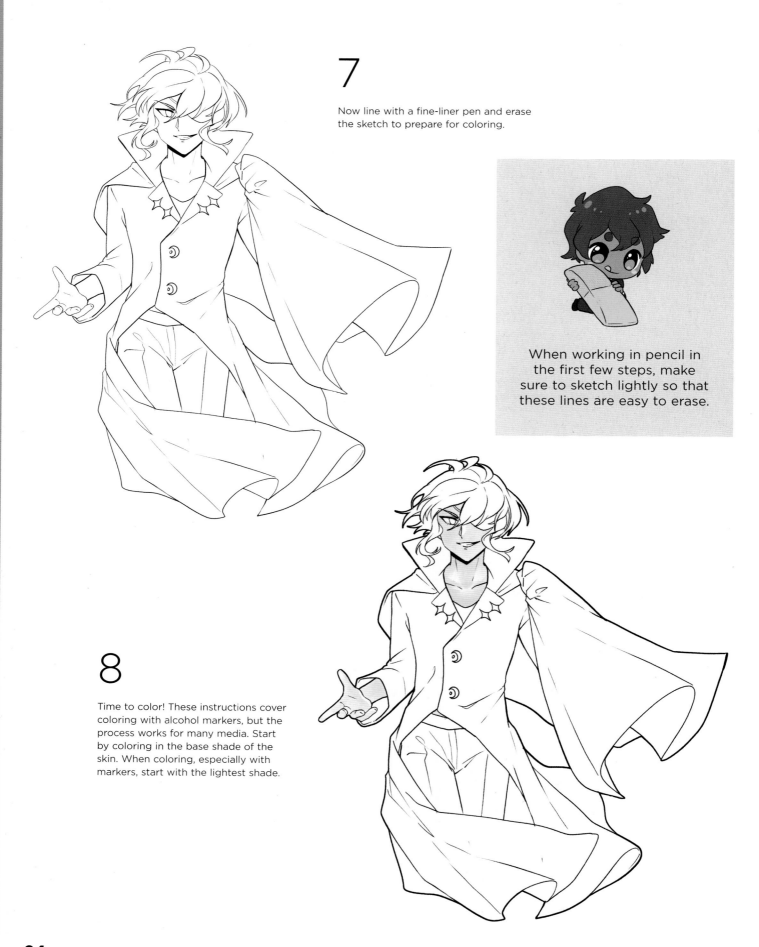

When working in pencil in the first few steps, make sure to sketch lightly so that these lines are easy to erase.

8

Time to color! These instructions cover coloring with alcohol markers, but the process works for many media. Start by coloring in the base shade of the skin. When coloring, especially with markers, start with the lightest shade.

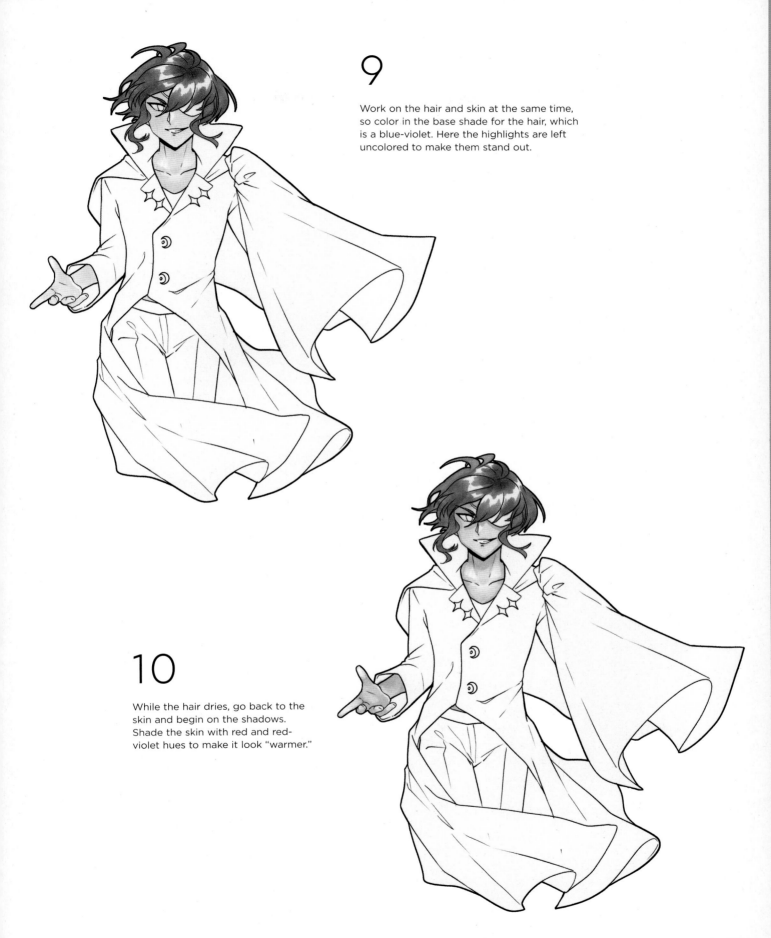

9

Work on the hair and skin at the same time, so color in the base shade for the hair, which is a blue-violet. Here the highlights are left uncolored to make them stand out.

10

While the hair dries, go back to the skin and begin on the shadows. Shade the skin with red and red-violet hues to make it look "warmer."

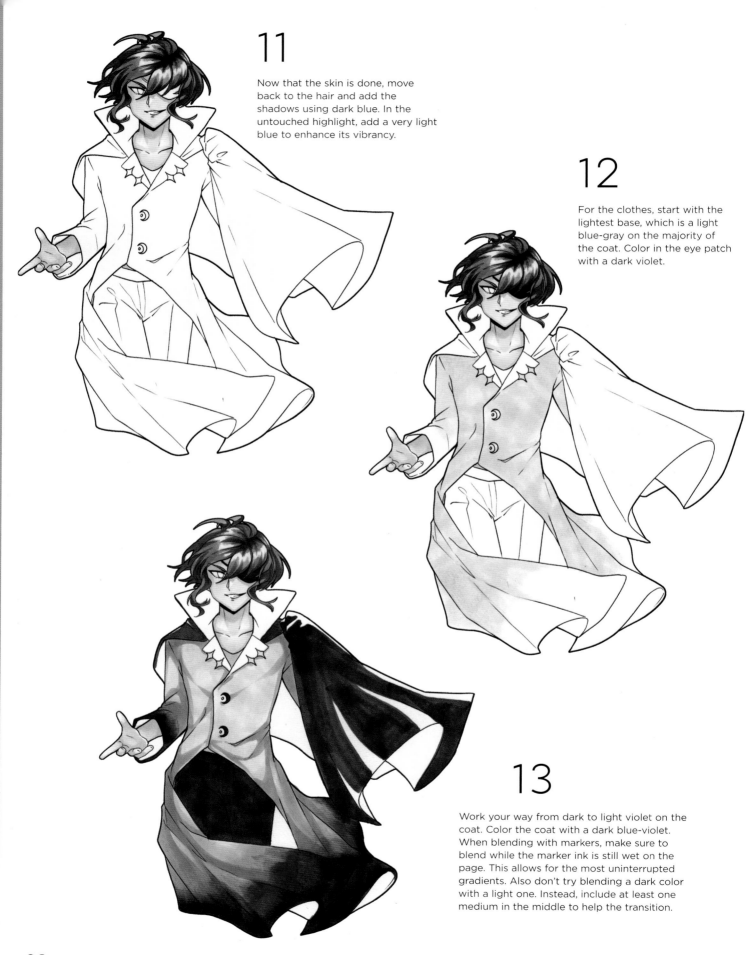

11

Now that the skin is done, move back to the hair and add the shadows using dark blue. In the untouched highlight, add a very light blue to enhance its vibrancy.

12

For the clothes, start with the lightest base, which is a light blue-gray on the majority of the coat. Color in the eye patch with a dark violet.

13

Work your way from dark to light violet on the coat. Color the coat with a dark blue-violet. When blending with markers, make sure to blend while the marker ink is still wet on the page. This allows for the most uninterrupted gradients. Also don't try blending a dark color with a light one. Instead, include at least one medium in the middle to help the transition.

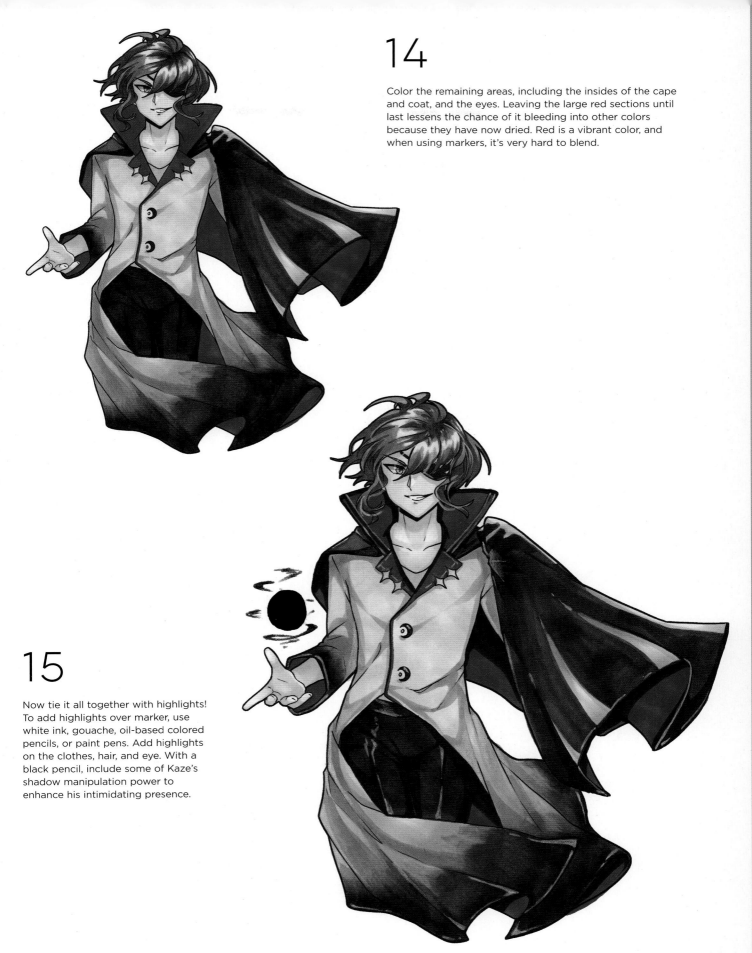

14

Color the remaining areas, including the insides of the cape and coat, and the eyes. Leaving the large red sections until last lessens the chance of it bleeding into other colors because they have now dried. Red is a vibrant color, and when using markers, it's very hard to blend.

15

Now tie it all together with highlights! To add highlights over marker, use white ink, gouache, oil-based colored pencils, or paint pens. Add highlights on the clothes, hair, and eye. With a black pencil, include some of Kaze's shadow manipulation power to enhance his intimidating presence.

SIDEKICKS

A hero's sidekick helps and supports them throughout their journey. Sometimes they join the protagonist on quests, or maybe they are just the hero's best friend, providing support when the hero needs it the most. A sidekick's personality is often opposite to the protagonist, which gives the hero have an expanded point of view. The sidekick will support them but also challenge them in ways that helps them grow and mature throughout the story. Many villains also enlist the help of a sidekick, or a minion, but not always. Some villains prefer to work alone. Minions tend to be comedic, incompetent helpers that ultimately hinder the antagonist in their efforts to thwart the hero. They will have at least one good or useful feature, though, an ability the villain desires to have, which explains why they keep them around.

HERO SIDEKICK

Here is Kira Moon's sidekick, Orion. They have a bright, shining personality and warmth that complements the hero's personality. They are energetic and loyal, and a little clumsy at times.

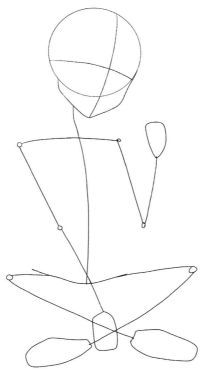

1

Begin with the stick figure guide. Orion is seated cross-legged, which is a more challenging pose to draw. Keep the perspective of the legs in mind as you draw.

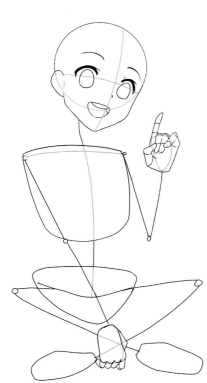

2

Add facial features and hand details. Orion has large, wide eyes to reflect their energetic and childlike personality. Add the upper torso and hip guides to help draw the rest of the body.

3

Using the stick figure as a guide, draw the whole body and their hair.

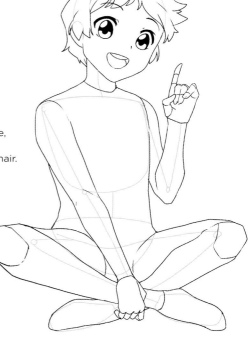

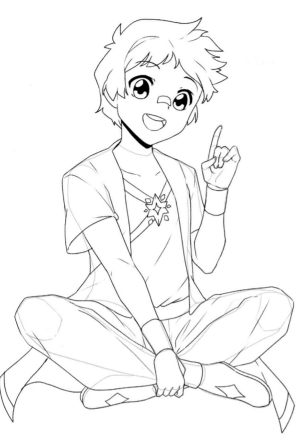

4

Now with the body established, draw in the outfit. Orion's clothing style somewhat mimics Kira Moon's kimono style, while their color palette of orange and purple complements her blue and purple.

5

To finish the drawing, line with a liner pen, and erase the guidelines. Finally, add color, keeping in mind that because orange is a vibrant color, you will start with a much lighter yellow-orange and build up to the stronger oranges.

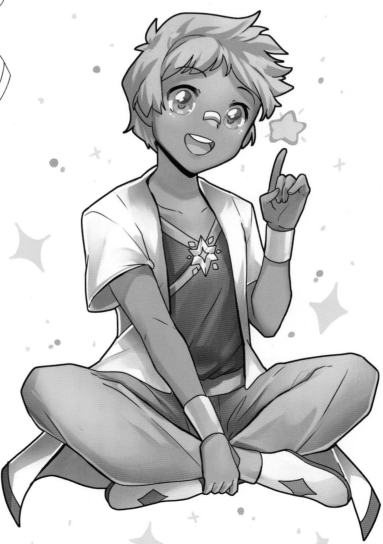

VILLAIN'S MINION

Kaze Moon's minion is Nako! An extremely smart robotic engineer, Nako's most prominent and problematic flaw is her incredible laziness. Nako will find any excuse to nap and is known to take excessive breaks when working on something for Kaze. Her comedic and well-meaning robot, Gogo, tries to help her with projects but usually ends up getting in the way, resulting in many explosions in her laboratory.

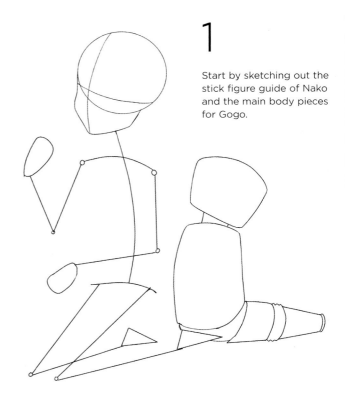

1

Start by sketching out the stick figure guide of Nako and the main body pieces for Gogo.

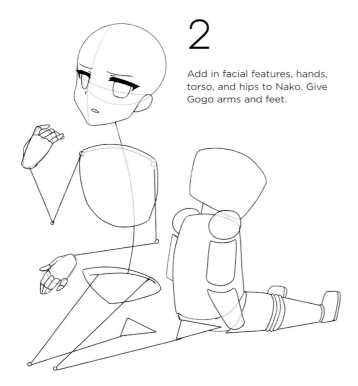

2

Add in facial features, hands, torso, and hips to Nako. Give Gogo arms and feet.

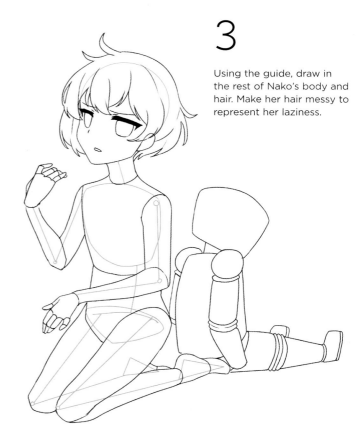

3

Using the guide, draw in the rest of Nako's body and hair. Make her hair messy to represent her laziness.

4

To finish off the sketch, draw in Nako's outfit. Her clothes are comfy and loose-fitting. Include a large pillow that she takes everywhere in her arms. Draw in Gogo's smile and antenna.

5

Once the sketch is complete, line with a liner pen and erase the sketch. Then add color! Nako isn't a flashy person, so keep colors neutral. To emphasize her tired and unmotivated personality, don't add too many highlights to her eyes.

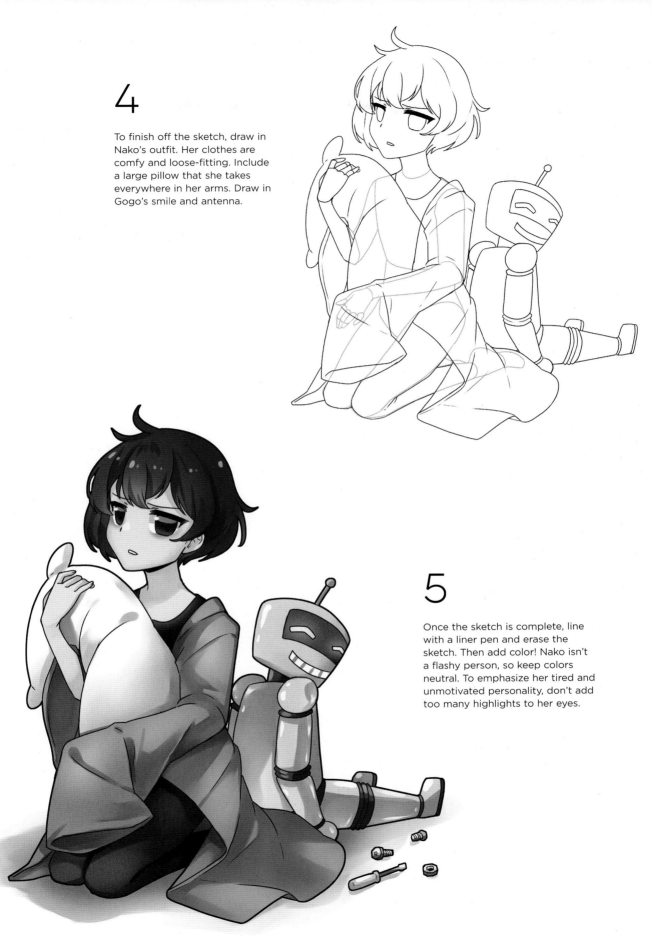

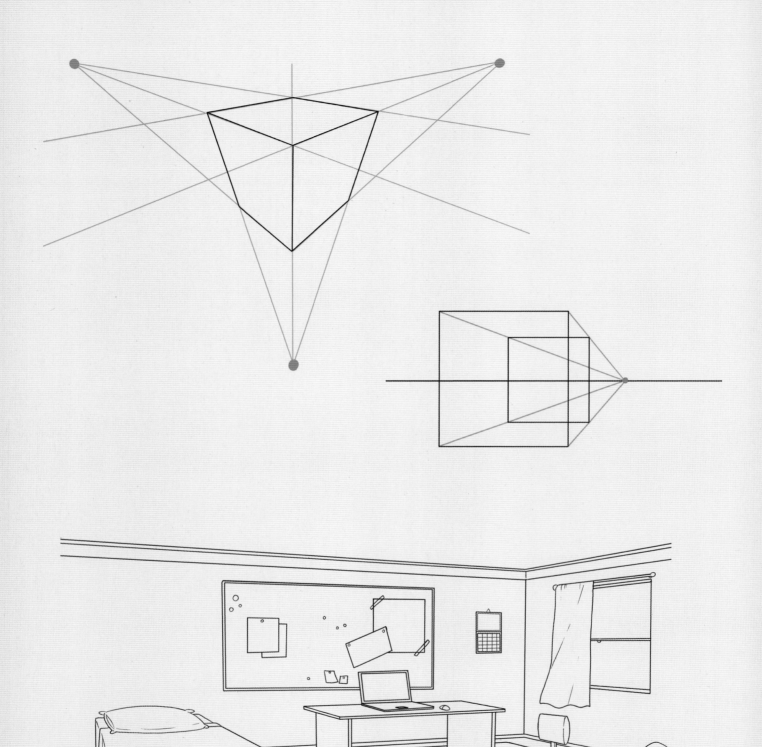

Chapter 6
FULL SCENES

DRAWING ENVIRONMENTS

Now that we have our heroes, our villains, and every character in between, it's time to place them in an environment! When drawing a character in a scene or interacting with objects, it is crucial to know how to draw in perspective. With this technique, you use converging parallel lines to know how and where to draw a person or object on a two-dimensional surface while giving it the illusion that it is in a three-dimensional space.

PERSPECTIVE

It will take time to be able to correctly apply perspective in your own work, so be patient with yourself. The key is to practice and draw from life as much as possible to understand objects in three-dimensional space.

One-point perspective includes a horizon line and one vanishing point (step 1). A vanishing point is a point where perspective lines converge, "vanishing" over the horizon. If you place a square onto your scene (step 2), it still looks like a flat shape. Draw lines from each corner that all meet at the vanishing point (step 3) and you can start to build the square into a cube. Draw another smaller square that follows the lines you drew (step 4) and finish off your cube by connecting both squares and erasing the extra guidelines (step 5).

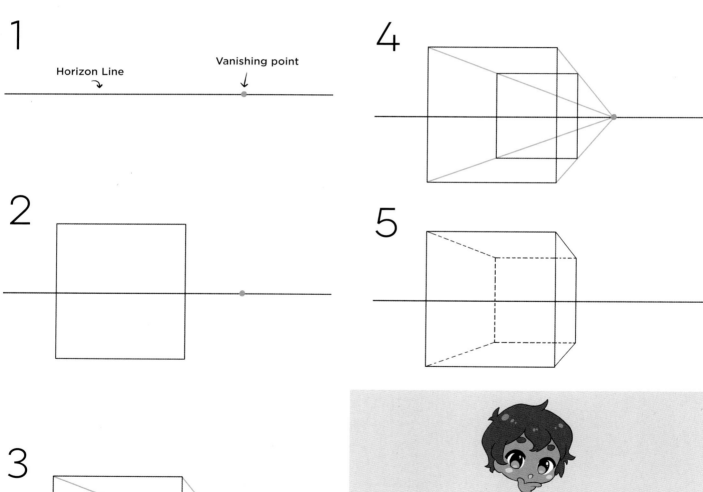

1

Horizon Line

Vanishing point

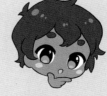

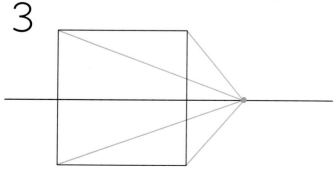

When in the early stages of learning perspective, use large sheets of paper and draw in the vanishing points at the very edges. That way you will always have a point of reference and can draw lines from the points directly. Once you become more confident, you can start drawing environments without physically plotting some or even all of the vanishing points.

Two-point perspective introduces two vanishing points to allow the viewer to see two sides of an object receding to each vanishing point. This is a popular perspective type when drawing objects and scenery. Keep in mind that both vanishing points should be spaced far from one another to allow for the most natural and pleasing angles.

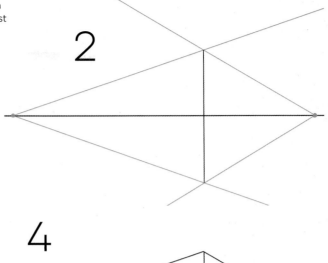

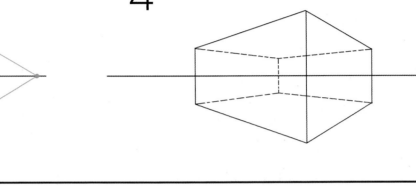

Three-point perspective is the most challenging but dynamic perspective. The more notable feature of this perspective is you don't have to include a horizon line. Use this perspective when viewing something from above or below. Like with two-point perspective, space each vanishing point far away to avoid the perspective looking cramped or unrealistic. The bottom vanishing point governs the height, while the left and right vanishing points govern the depth of the object to their respective sides.

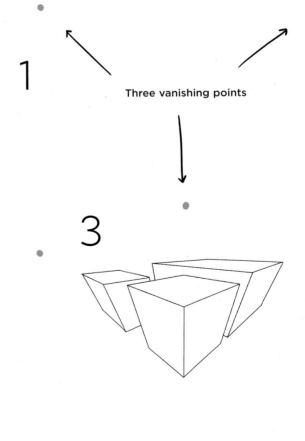

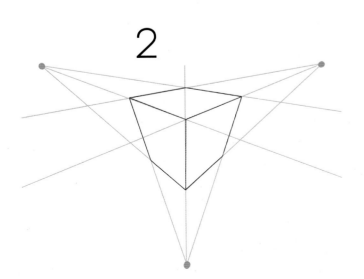

COMMON OBJECTS IN MANGA

Regardless of the genre of manga you create, you will eventually need to draw your characters interacting with objects—otherwise your manga would look boring! Here are some everyday objects you could include in your story.

Bags are easier to render if you can draw a rectangle in two-point perspective. This bag design is common for Japanese high school students.

Books are great for practicing perspective. Once you can draw one book, all you need to do to create a stack of books is to pile them on top one another! If you're having trouble keeping the perspective correct, draw each book fully, and then erase the overlapping lines.

Electronics, such as phones and laptops, begin with very thin rectangular prisms.

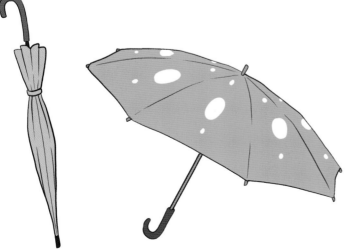

Umbrellas, while not something you may need to draw a lot of, are great objects to practice drawing from photo references showing different angles. It comes with its own set of challenges as it is a peculiar shape to draw.

Magical objects can include staffs, orbs, seals, and shields. They can be used for adding to the design. In the manga world, anything ordinary can become extraordinary. Consider the character and purposed of the object, and design accordingly.

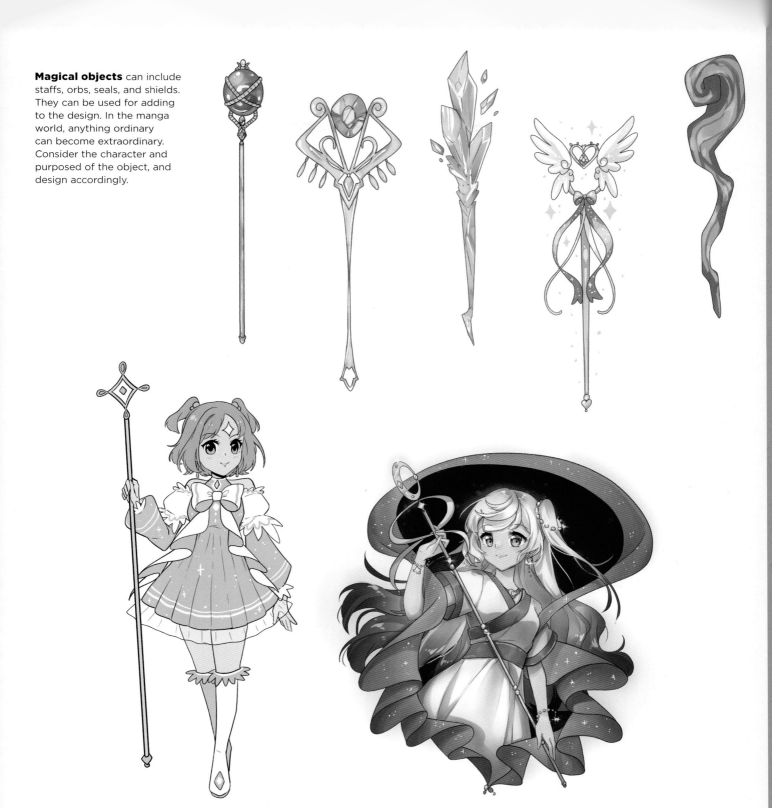

Consider how the character may interact with the objects as well. Because it's in a supernatural setting, maybe the object defies gravity and floats around the character! A small detail like this adds to the atmosphere.

SCENES, STEP BY STEP

Using what you have learned about one-, two-, and three-point perspective, apply that to drawing different settings for your characters. In this section you can practice drawing a peaceful garden, a bedroom, and a bird's-eye view of a city—all in perspective!

OUTDOOR GARDEN SCENE

Start with this outdoor setting in one-point perspective. This example is a garden, but these steps can also be used to draw suburban or cityscapes too.

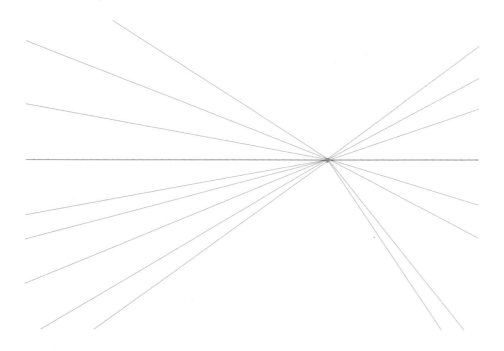

1 Draw the horizon line across the center of your page and place the vanishing point just off-center toward the right. From the vanishing point, draw lines to follow before you start adding the garden details.

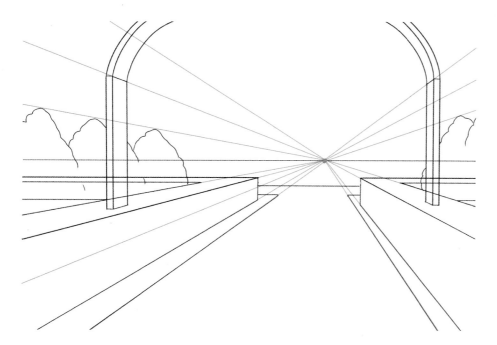

2 Referencing those lines, start to draw in the bushes, trees, archway, and path. During this drafting stage, keep to basic shapes and avoid going into detail just yet.

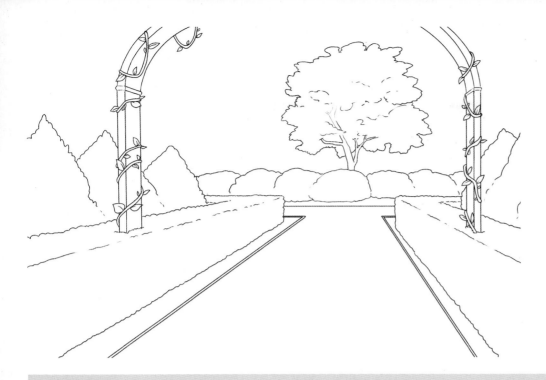

3 Now it's time to add the details! Instead of straight, stiff bushes, use the shape you drew as a guide and draw in the bushes using wavy and bouncy lines to suggest leaves. Add details to the arch, such as a vine growing around it. At the end of the path, add more bushes and a nice big tree to give the scene a focal point.

 If you think the very back of the scene looks a bit empty, add a simple tree line with large clouds on the horizon to fill it out. Don't outline these elements but add them during the coloring stage. Because they sit in the very back of the scene in the distance, outlining them would clutter the drawing.

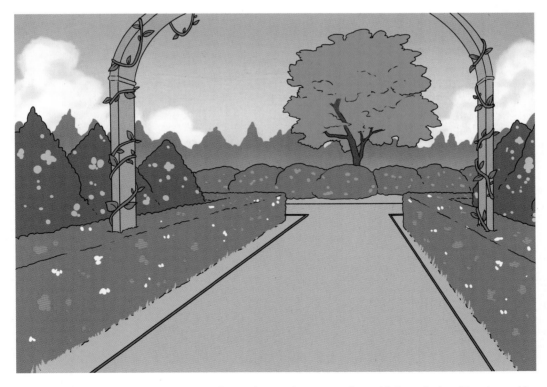

4 Using a black ink pen, outline your setting and erase the perspective guidelines. Go in with color and have fun experimenting with a color palette. This scene is colored in a spring palette with multicolored flowers filling the different bushes, but you can get an autumnal feel by changing the leaves from green to orange.

INDOOR BEDROOM SETTING

Using two-point perspective now, move indoors and draw a bedroom scene. You can use this process to make any room. Note that because of the close-up nature of the scene, the second (right side) vanishing point isn't visible on the page, as the vanishing points are spaced far apart. When drawing your room, feel free to place the points closer together when practicing, but keep in mind that doing so will change the perspective to the one shown here.

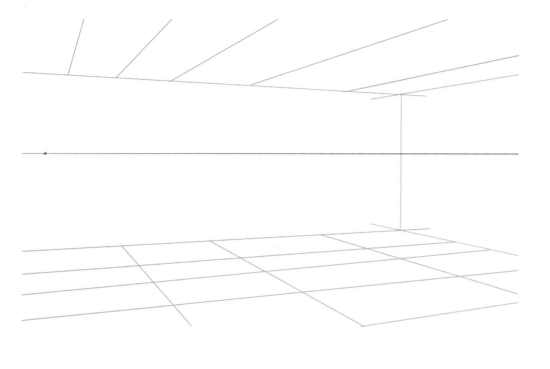

1

Draw the horizon line through the middle of the page and adding the vanishing points spaced far apart. The crucial first step is to build the foundations of the room—the walls, floor, and ceiling—using both vanishing points as a guide. A great way to get a sense of floor space is to draw a grid pattern on the ground that follows the vanishing points. This will help you see the perspective as you add features to the room.

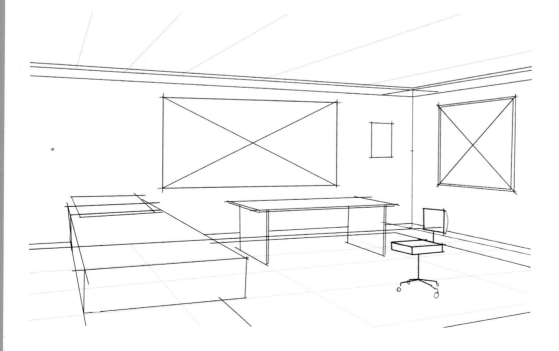

2

Now design the room! When adding windows, pictures, and other items on the walls, place them in the upper-middle part of the walls, not too high or low. Keep everything to basic shapes at this stage to help connect them to the vanishing points and remain in perspective. While drawing furniture, keep in mind the size you draw it. Make sure that a desk and chair, for example, doesn't look too tall or too short.

3

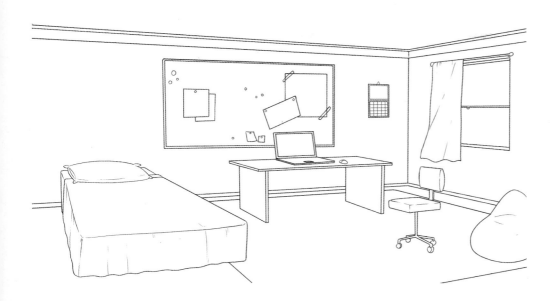

Bring it all together! If you used many guidelines and perspective lines while drawing, it's a good idea to get a fresh piece of paper and use a light box to trace the main lines onto the new paper. Now add the fine details into the room. If you want the room to reflect the character of the person who lives there, make sure to add things that tell a story about them. You could add trophies on a bookshelf, photographs of family on a desk, or band posters on the wall. A great way for a reader to learn about a character is by seeing that character's bedroom!

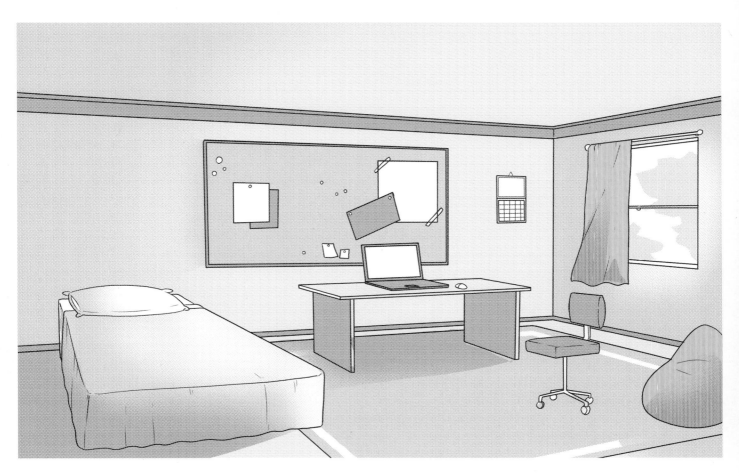

4a

When shading black-and-white scenes, the most important thing to keep in mind is the light source. In this scene, the light is coming from the slightly open window, which is reflected in the shadows that extend from things like the desk and bed. Make sure the shading makes sense with the direction of the light source.

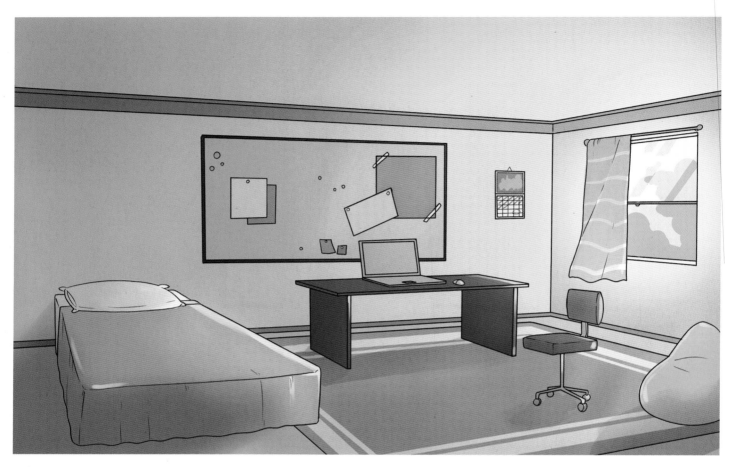

4b Color choice is important in indoor scenes, as these spaces are usually decorated for a specific reason or by a specific person. When coloring your piece, consider playing around with different color combinations and see what atmosphere it creates.

To find the middle of a square or rectangle on a wall that is affected by perspective, connect each diagonal corner to make an "X," and the point where they intersect is the middle. To make things look in line on a wall, just make sure the middle points of each shape are all on the same line.

BIRD'S-EYE VIEW

For this bird's-eye view, you will use the more challenging three-point perspective. A great way to make any scene look exciting is by using an uncommon perspective to view an environment. This environment is a town where the action will unfold.

1

For this perspective, there isn't a horizon line. Instead there are three vanishing points spaced far apart in a "Y" shape. There is one point in the top, left corner; one in the top, right corner; and one at the bottom, slightly off-center to the right. From each vanishing point, draw lines out to help get an idea of the perspective space you will be drawing in. Note in this example, the vanishing points are too far apart to be shown in the scene.

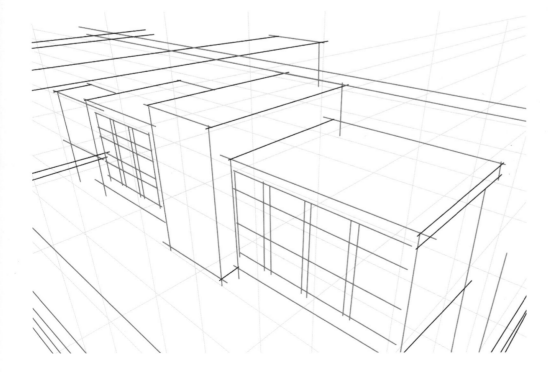

2

Referencing each vanishing point when needed, draw the basic shapes of the buildings. In this example, all of the green lines go toward the left vanishing point, all the blue lines go toward the right vanishing point, and the red lines go down toward the bottom vanishing point. Drafting in these different colors can sometimes help you get a better understanding of how the buildings should look in three-point perspective.

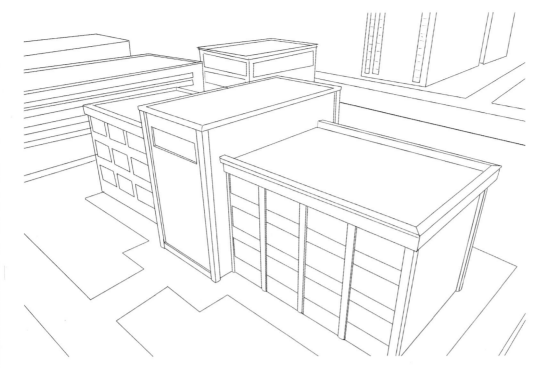

3

From those lines, begin adding the important details such as paths around the buildings, windows, and any greenery you may want to add.

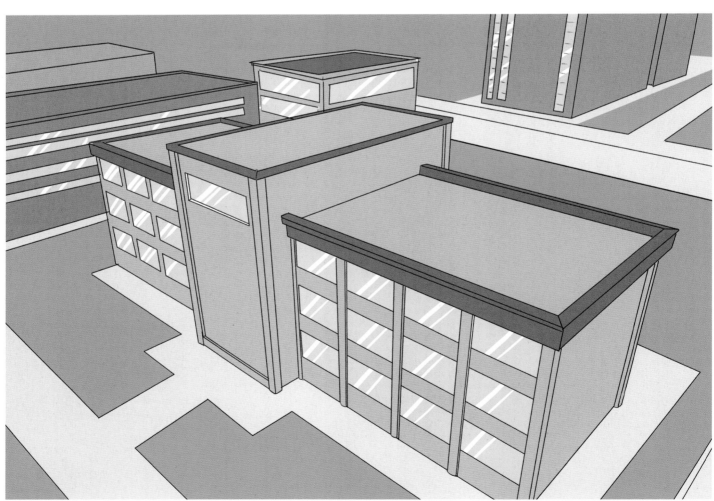

4 Line the drawing with a fine-line pen and begin coloring. Note that buildings usually take on various shades of warm and cool grays and browns. Color the windows whatever color the sky is in your scene. If it's sunny, the glass with reflect blue. If it's rainy, the glass will reflect gray.

5 (Optional) If you want to add action to the scene, draw in a dramatic event! In this case, a dragon is climbing over the building while two heroes arrive to try and stop it. For those drawing digitally, you can add a layer over your environment layers and draw in your characters. (The key to merging characters and environment is to draw them all in the same perspective! Don't forget about perspective when you're adding the people.) For those drawing on paper, sketch out any characters or creatures you want to add before the lining stage.

Remember, this perspective is challenging to get right, even for advanced artists. If you feel it's too overwhelming to try, come back when you get more confident in one- and two-point perspectives. It's all about practice, and every time you try, you will get better and more confident.

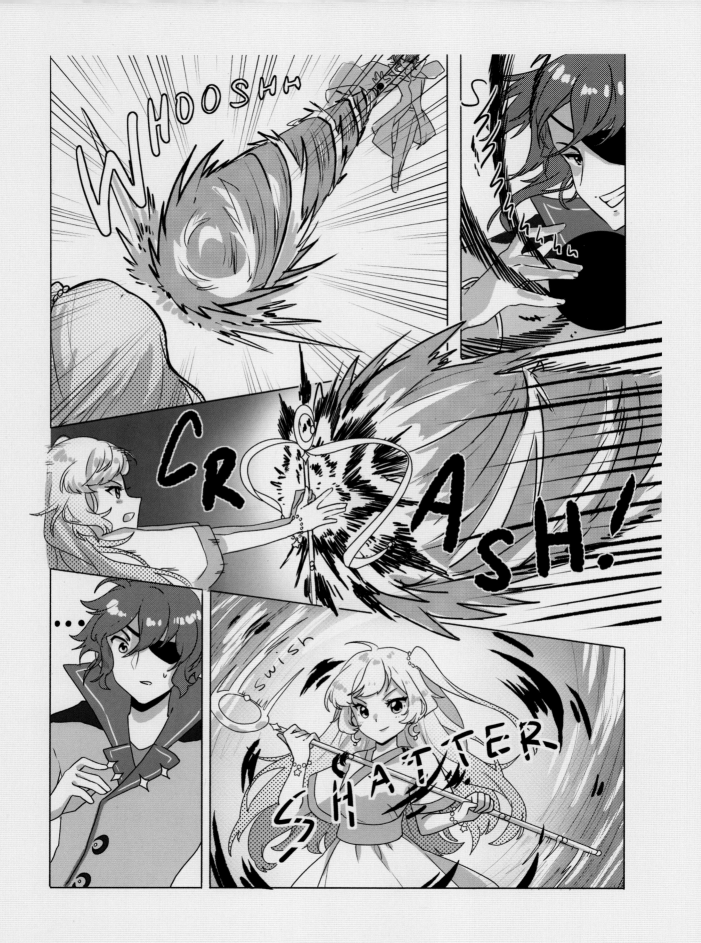

Chapter 7
MAKING YOUR OWN

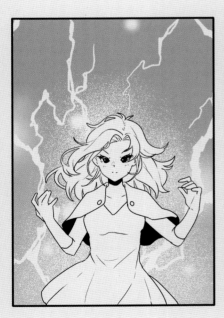
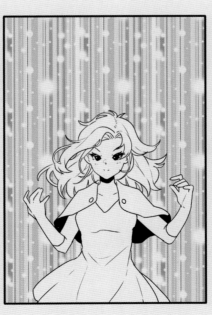
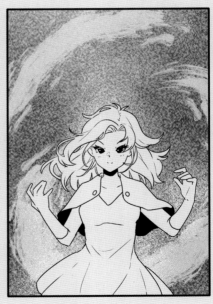

MAKING A MANGA BOOK

This section covers how to create simple manga pages and scenes. First you will learn about panels and page layouts, word balloons, sound effects, and overlays to achieve atmosphere. Then you can practice putting everything together by following the step-by-step guides to drawing several sample pages.

PANELS

Manga panels are the containers on each page that include the scenes, characters, and dialogue. Strategic layout of these panels helps the story flow. Typically, a manga page is read from the top, right to the bottom, left as per Japanese reading conventions. But as manga becomes more popular in Western cultures, many Western mangaka draw their stories left to right. It's up to you how you build your manga pages.

Try to limit your panels to one to six per page. Sometimes one panel can take up a whole page! Using fewer panels per page helps let each scene "breathe" and not feel too crammed, as well as making the manga more readable.

Instead of this...

try this!

Characters don't need to stay confined in the panel's boundaries (above). A great way to have a scene stand out is for the characters to break the panel lines and into the open areas of the page. Similarly, you also don't have to confine word bubbles in the borders of a panel (right). If a word bubble feels cramped, try having it sit on top of the panel borders. Spreading a speech bubble over two panels can also help lead the viewer's eyes to where they should go next. Learn more on word balloons on page 120.

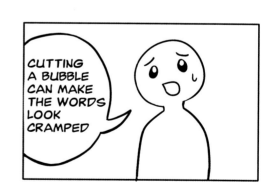

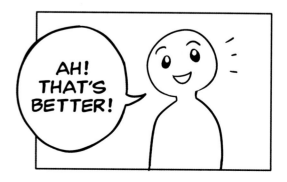

PANEL SHAPES & SIZES

Panels can be a wide variety of shapes and sizes. A large panel that covers most of the page can be used to establish a setting or to bring emphasis or climax to a certain point in the story. Small panels are used for quicker, fast-paced parts of the story where lots of things may be happening. Combine small and large panels on a page to give your reader a variety of things to look at. Panel shapes can also range from standard rectangles to irregular quadrilaterals of any size and orientation! Straight lines are used 99 percent of the time, but experiment with as many fun and different shapes as you'd like for your own storytelling.

USING PANELS TO AID ACTION

When action or drama strikes your scene, you can communicate a change of pace by shifting from horizontal and vertical panels to diagonal panels and layouts. These give the reader a sense of movement and urgency that help dramatize action sequences.

For the scene above, you'll see that there are a few large panels on two pages. One scene can stretch over multiple pages depending on how significant it is. If an action scene is important in your story, give it the room it deserves! You'll also see a dramatic perspective in the last panel. When done correctly, panels with dramatic perspectives can really enhance the impact of a particular scene. Having a fist look like it's coming at you has more impact than seeing the punch from afar. Finally, the "BAM" sound effect and glove are breaking the panel borders, which allows for extra impact at the climax of the scene.

WORD BALLOONS

Word balloons don't just contain the words a character says. They also aid the reader in understanding the tone and emotion that was used by the character. Avoid using too many different kinds of balloons on one page, as that can distract from the characters and the scene. Also try to limit word balloons to one to three sentences. If you find yourself writing too much, then add more panels to spread the dialogue out!

The shapes of the word balloons vary to show whether a character's speaking voice is relaxed and casual, happy or excited, angry, or trembling. In manga, they either have a small balloon tail or none at all.

I AM A CASUAL DIALOGUE BALLOON. USE ME FOR CASUAL CONVERSATION BETWEEN CHARACTERS.

I AM A TREMBLING DIALOGUE BALLOON. USE ME IF A CHARACTER'S VOICE IS SHAKY.

I AM A HAPPY EXPRESSION BALLOON! USE ME WHEN A CHARACTER IS HAPPY OR EXCITED.

I AM AN ANGRY SHOUT BALLOON! USE ME WHEN A CHARACTER IS YELLING.

OUT-OF-SHOT CHARACTER

If you have a character not shown in the scene talk, use an inverted balloon tail to show that the speech isn't coming from any of the characters drawn in the panel.

SOUND EFFECTS

In manga, sound effects are written out using onomatopoeia. Most of these phonetic sounds are self-explanatory, but occasionally you will come across sounds or situations that may be harder to describe. When this happens, get creative! Just as each manga artist has a unique art style, each person can describe sounds differently in their stories.

A feature of sound effects that is almost more important than the word itself is how the word is written or drawn. A soft tapping of shoes on the floor should be written small, but an explosion should be large with thick letters and could include patterns or color. Bring life and different meanings to your sound effects by making sure the way they are written matches the sound volume in the story.

Rain can be written out with a small "shaaaaaa."

Walking is often shown as "tmp tmp tmp" or "tp tp tp."

Explosions are represented with a big "KA-BOOM, "CRASH," "POP," or "BOOM!"

Small kisses are written as "chu~."

Depressed and gloomy atmospheres, which are exaggerated and usually used comedically, are often accompanied by a "dooooooon" sound effect.

Heartbeat sounds often accompany blushing and signify the racing heart of someone who's in love. This sound is shown as "doki doki" in Japanese-language manga and "ba-dump ba-dump" in English-language manga.

OVERLAYS

The finishing stage of creating a manga, after lining it all, is adding manga screentones. Screentones are a semi-transparent, adhesive film with different patterns on them that you cut and stick onto your manga to add shadows, textures, gradients, and atmosphere. Depending on where you live, it can be hard to source screentones, as they are predominantly sold in Japan. If you don't have access to screentones, an alternative is to use pens and monochromatic markers to re-create similar effects and shading. Here are four popular screentone overlays used to give a scene a distinctive atmosphere and feeling.

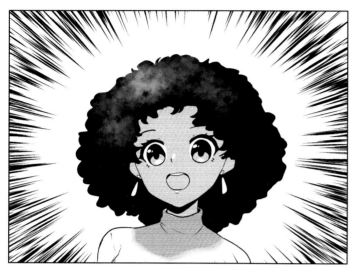

Motion lines are used when a character is shocked or surprised.

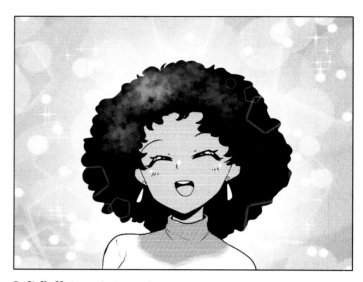

Soft fluff shows feelings of happiness, contentment, and love.

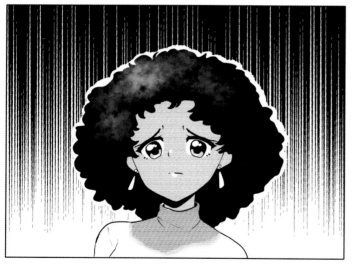

A downward-flowing gradient provides a gloomy or moody atmosphere.

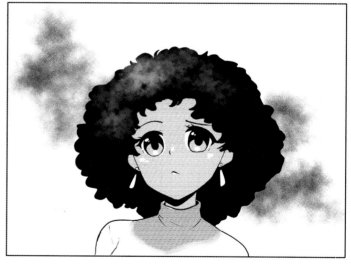

A cloudy atmosphere signifies that a character is planning or thinking, or if something is on the character's mind.

Behind a professional mangaka is usually a whole team behind them who help. Because deadlines can be too short for one person to manage, there are manga assistants. These assistants draw backgrounds and environments, line each page, add screentones, or color. These assistants are usually up-and-coming manga artists who take on these jobs to get a foot into the industry and be taught by an established mangaka. This is also the perfect job if you like drawing specific parts of a manga but not necessarily the whole thing.

ACTION EFFECTS

Apart from character poses and page layouts, there are other ways you can add a bit more dynamic action into your scenes.

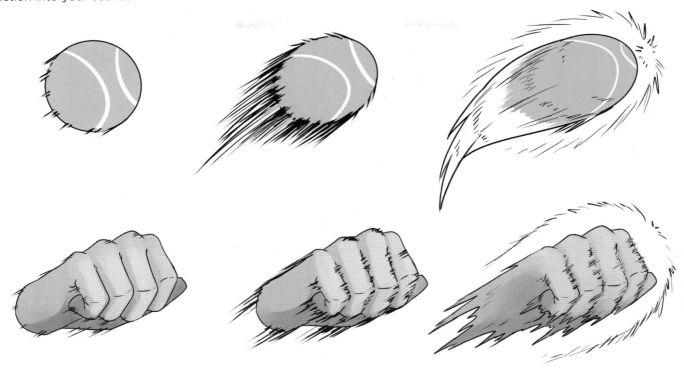

Speed lines are useful when a character or object is moving fast. The lines blur and stretch, indicating the speed of the object. Experiment with a different number of lines to see how it affects the way a reader will interpret the movement.

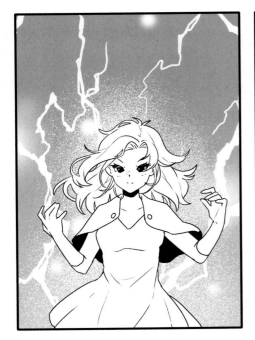
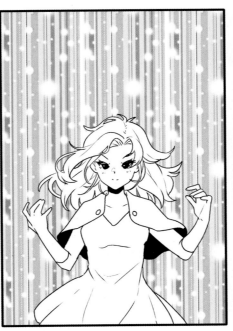
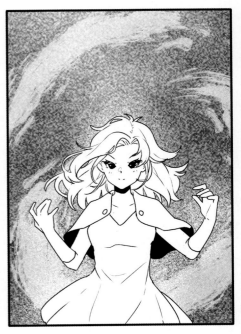

Power auras convey a character's incredible power. Use lightning bolts, power swirls, or whatever you feel best represents the character and their potential. Once again, experiment!

SEQUENCES, STEP BY STEP

Now that you know about panels and page layouts, word balloons, sound effects, overlays, and other special effects, it's time to begin putting everything together. Use these sample pages to practice, keeping in mind that you can use these same steps as you create your own manga.

JAPANESE FESTIVAL MANGA PAGE

On this page, the character sees the fireworks begin at a Japanese summer festival.

1 Begin by roughly drafting the page. This page features a wide first panel to set the scene, a borderless panel of the character turning around to see the fireworks, the fireworks panel, and then a close-up of the character's eyes in reaction to seeing the fireworks.

2 Now complete the line art! Using an ink pen or dip pen, line the panels and the contents in each panel. In this digitally rendered example, the fireworks and night sky will be added using a screentone overlay effect, but you can draw these if you'd like. This is also the time, if you are drawing this traditionally, to make sure to line in the speech bubbles.

3 Add the sound effects and speech. If you are drawing digitally, add the speech balloons on the top layers after you've completed step 4.

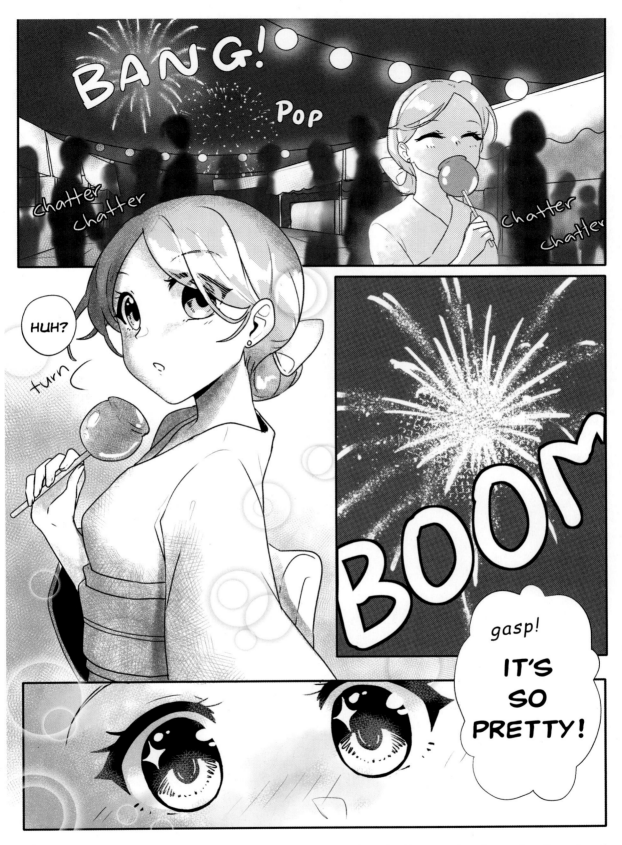

4 Lastly, add in screentones and overlays to shade and create atmosphere. As this atmosphere is one of excitement and wonder, use soft shading gradients to give a romantic, dreamy feel to the scene. You can use gray markers or pencils to create shading and effects.

MANGA ACTION SCENE

Now that you have practiced how to make characters and objects look like they are in motion with dramatic, action-packed scenes, try drawing your very own action scene! This will be a battle between the hero Kira Moon (see page 84) and villain Kaze Moon (see page 92). This manga page is laid out in the traditional Japanese reading order of right to left, beginning at the top, right corner panel.

1

At the rough-draft stage, you can be as messy and experimental as you want. Play around with panel sizes and shapes. Build action with speed lines and power-aura backgrounds.

2

Now that the bare bones of the page have been started, begin to clarify and neaten panels, and add in sound effects or any dialogue. Neaten and redo your drafts as much as you like before moving on to the line-art stage.

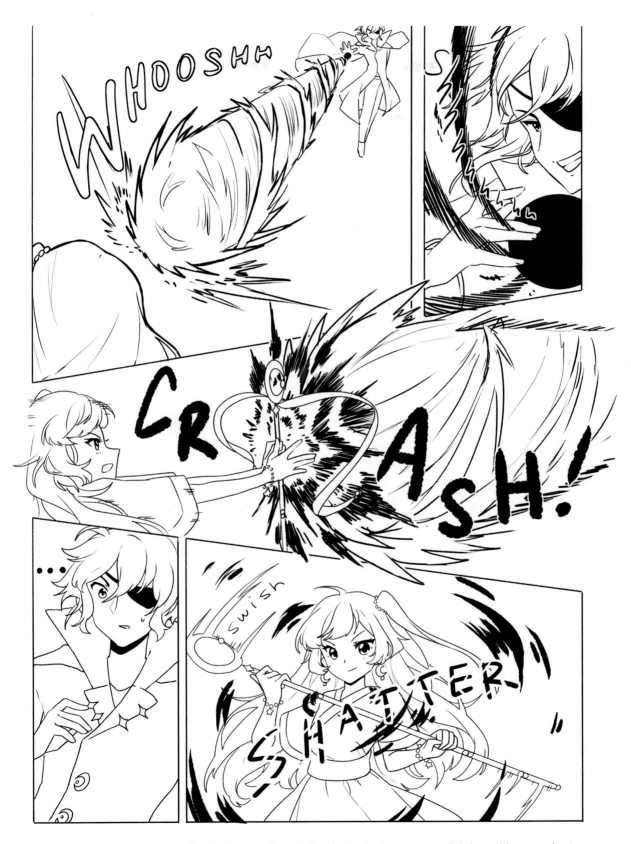

3 Using a liner pen or dip pen, begin the page line art. For the best outcome, use a lightbox with a new sheet of paper for the final. Don't be afraid to use bold lines or full black to enhance the contrast in each panel. Add the sound effects.

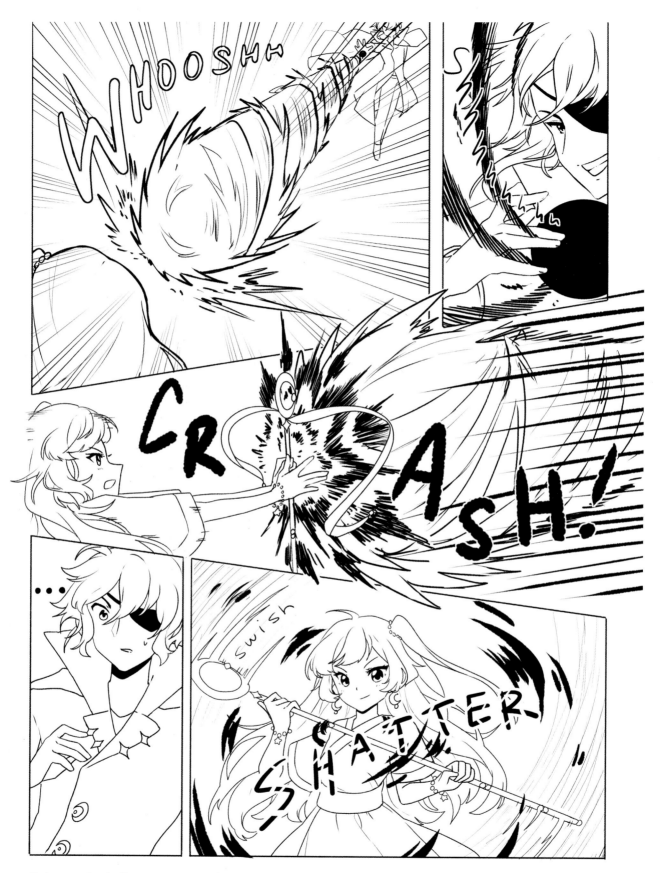

4 Before moving to the screentones and overlay stage, continue using your inking pen to add action lines to give momentum to the series of events in the panels. Make sure to use a ruler for the straight lines!

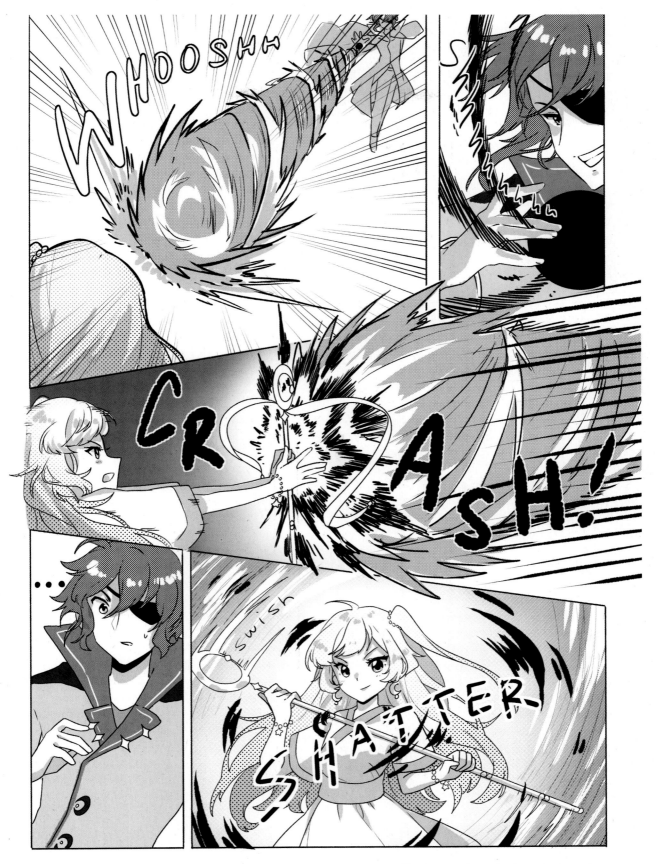

5 Lastly, add shading and background atmosphere with screentones or gray pencils or markers. For important panels, use a lot of contrast for a dramatic atmosphere. And with that, you have finished your action manga scene!

DEVELOPING YOUR STYLE

As you are developing your unique style, realize that it will take time. Practice a lot, experiment, accept that you will have art that you won't be happy with, and make sure to stop comparing yourself to other artists. Instead, look back every once in a while to compare your old work to your current work! Watch and appreciate your style progression, no matter how long that may take.

EXPERIMENTAL EXERCISE

Here is an exercise that can help you experiment and over time develop a style that is unique to you.

1 Find art you like! Search high and low for at least 10 artists whose art style you love.

2 Analyze each artist's work. What do they do that appeals to you? Is it how they draw hair, eyes, or clothing? Is it how they line the art, shade, or add highlights? Is it their characters' anatomy or a special way they render backgrounds?

3 Take one feature from the art you love and apply it to one of your own drawings. If you like it, try it again. If you don't like it, don't do it again. Repeat this over and over, and soon you will see you have your own unique style!

TRACING & REFERENCING

There is a big difference between copying another artist and using their work to help you develop your own style. Both of the sketches below were created using the image on the left-hand page as a reference. One is a bit too close to the original to call it a brand-new piece (left), but the other became an original work (right).

Often there is a stigma around tracing, but it can be a great way to speed up practice sessions and for your hand to acquire muscle memory for some things that may take longer to figure out without it. In the image above, for example, the traced image is different from the original drawing pictured on the opposite page, including the facial expression and some of the clothes. When used in this way, tracing can be valuable practice. (The key word here is practice. Of course, you should never claim traced art as your own work.)

You can also collect images that you like to use as reference for new drawings. The character above was also created using the same reference image from the opposite page. But the reference image served as inspiration for an entirely new piece. This new drawing doesn't look too similar to the reference image, as a variety of references were used in its creation. Collect all kinds of images that you can use to help you draw.

MAKING PROGRESS

If you aren't yet confident with your drawing abilities, don't give up! Keep practicing and experimenting, and you will see progress. For example, here is my progression over many years, which may encourage you.

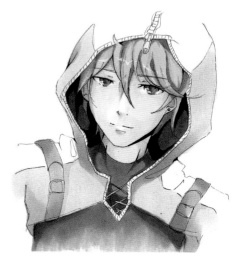

When I first started drawing manga, I was inspired by every single magical girl anime available to me. I didn't care about my art looking good. I just had ideas in my head that I wanted to see on paper, so that's what I did!

After learning more about manga and reading quite a bit, my art style fluctuated a lot. I didn't have my own style at this stage, but I experimented a lot.

I began studying art and drawing from life, and not just manga styles. I experimented with coloring and different media. I now started to find my own style.

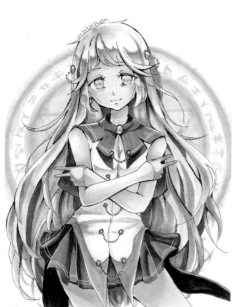

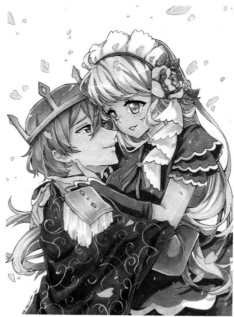

After a few years of life drawing and coloring practice, I understood anatomy and color theory. At this point, my art style really matured.

A couple of years later, I truly discovered a style that was working for me. I was creating my own characters, stories, and working as an artist almost full-time.

To this day, I continue to hone and refine my skills, learning better ways to shade, trying more complex poses or compositions, and stepping out of my comfort zone any chance I can. Each attempt helps me grow.

WHERE TO GO FROM HERE

Now that you've reached the end of this book, you may be wondering, "Now what?" One of the most common questions asked by emerging manga artists is, "How do I get noticed?"

You are your own best advocate. No one else will be with your art as much as you will, so if you want others to know about it, you need to show it to them! Make a social media art account and post your art for the world to see! Ways to increase your exposure is by entering competitions, participating in "draw this in your style" challenges that other artists host, and connecting with other users who share the same passions as you do. Instead of basing your art's worth on follower count, think of social media as a way to gain connections and possible exciting opportunities in the future. For those of you who want to pursue manga art as a side gig or career, after you establish your social media, you can try moving on to whatever you are interested in, whether it be selling art, creating comics, or getting into digital animation. The most important thing is never to stop creating!

Continually grow your style and your storytelling. If you do this, no matter what happens, people will start to notice. They will notice the passion in you and your characters and art. And once that happens, the sky is the limit. So why are you still reading? Get to drawing!

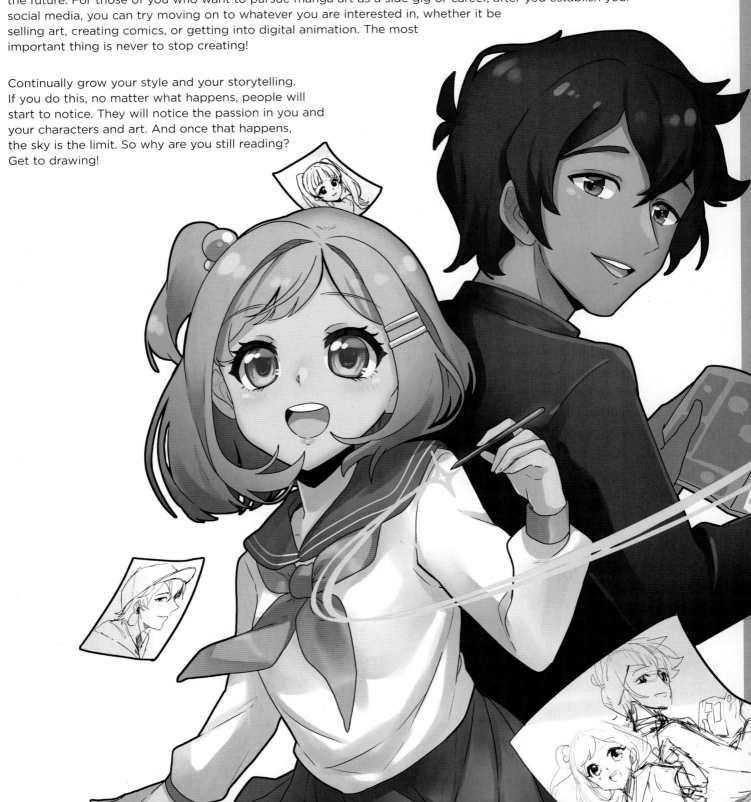

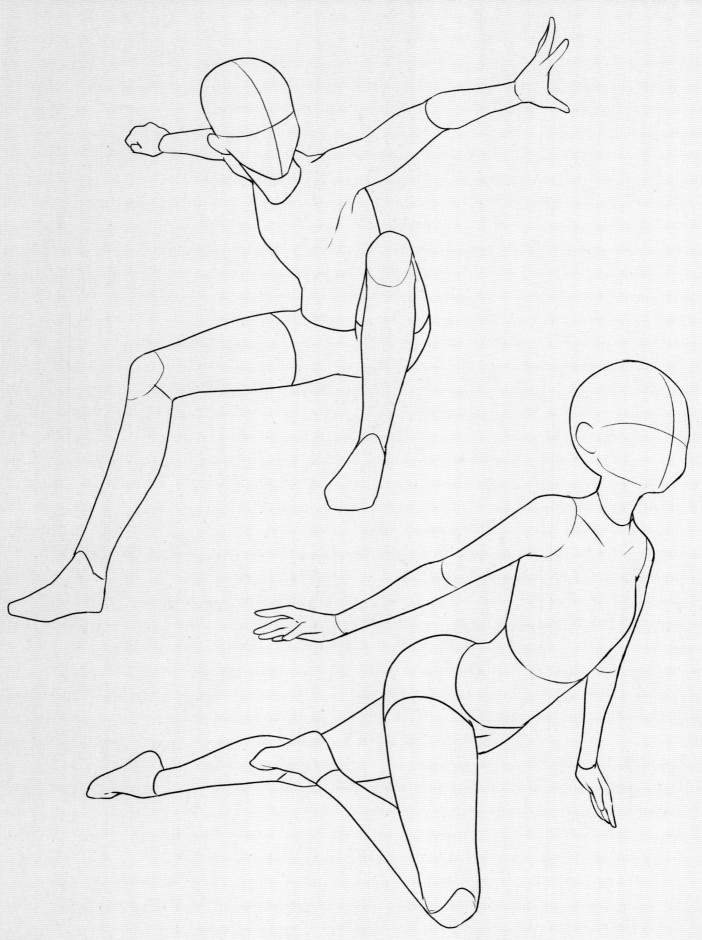

Chapter 8
TEMPLATES

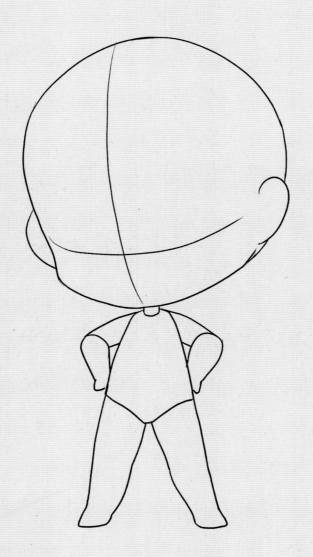

HEADS

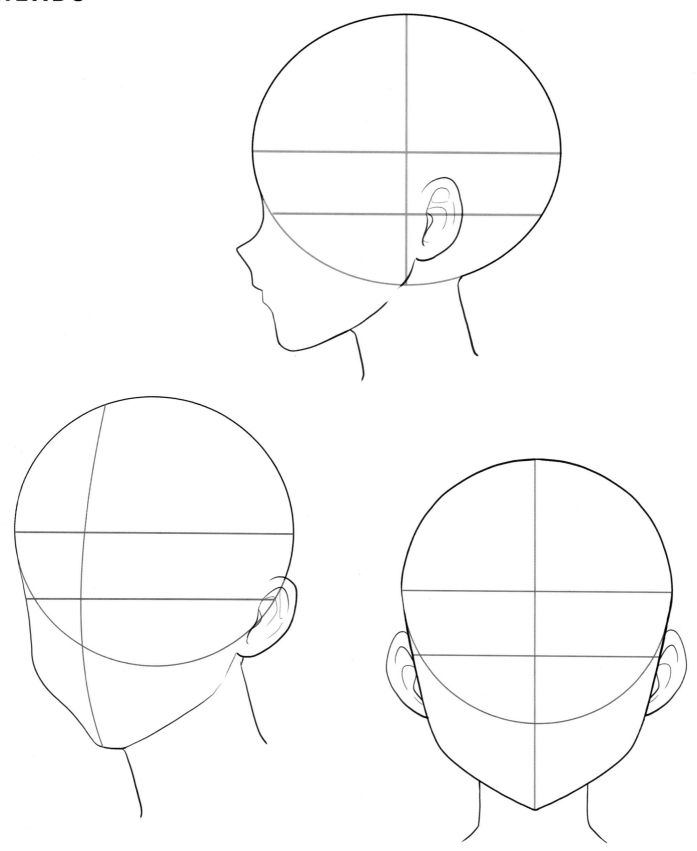

STANDING BODY POSES

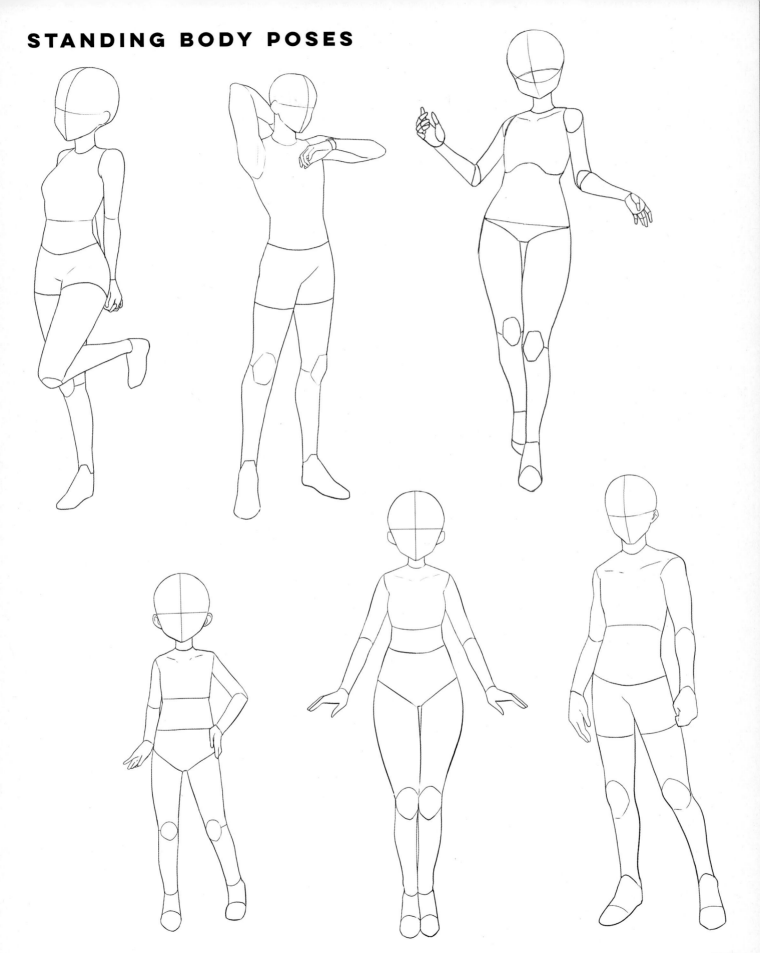

ACTION POSES

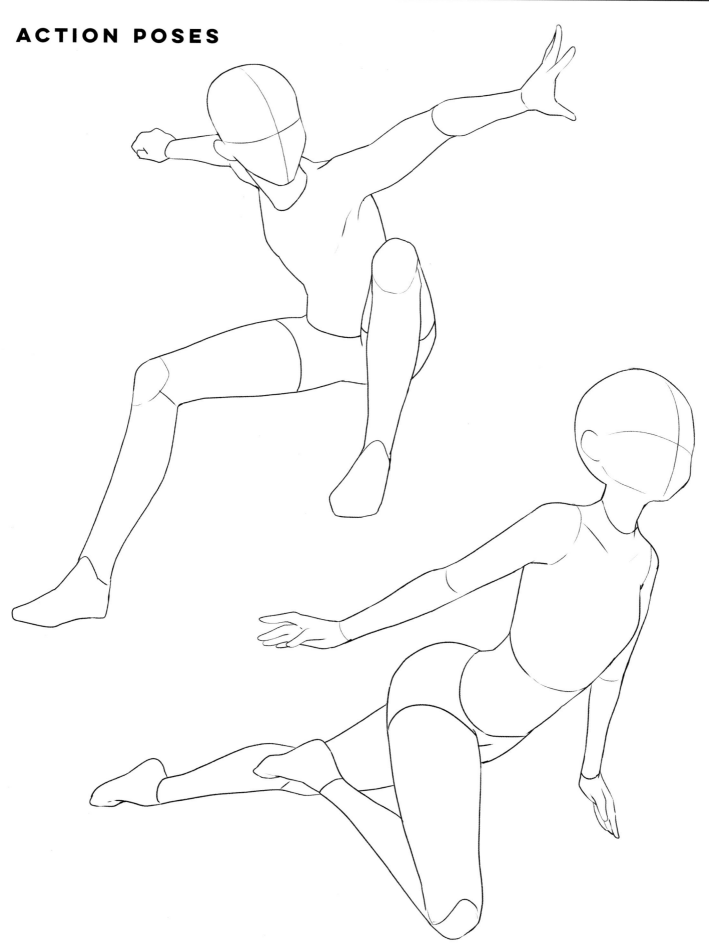

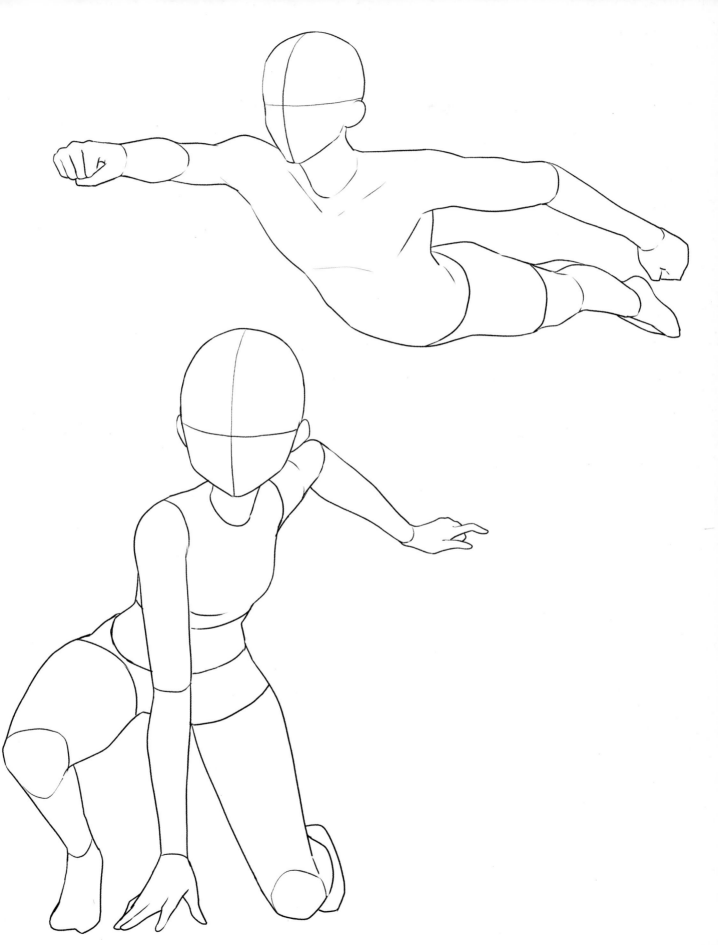

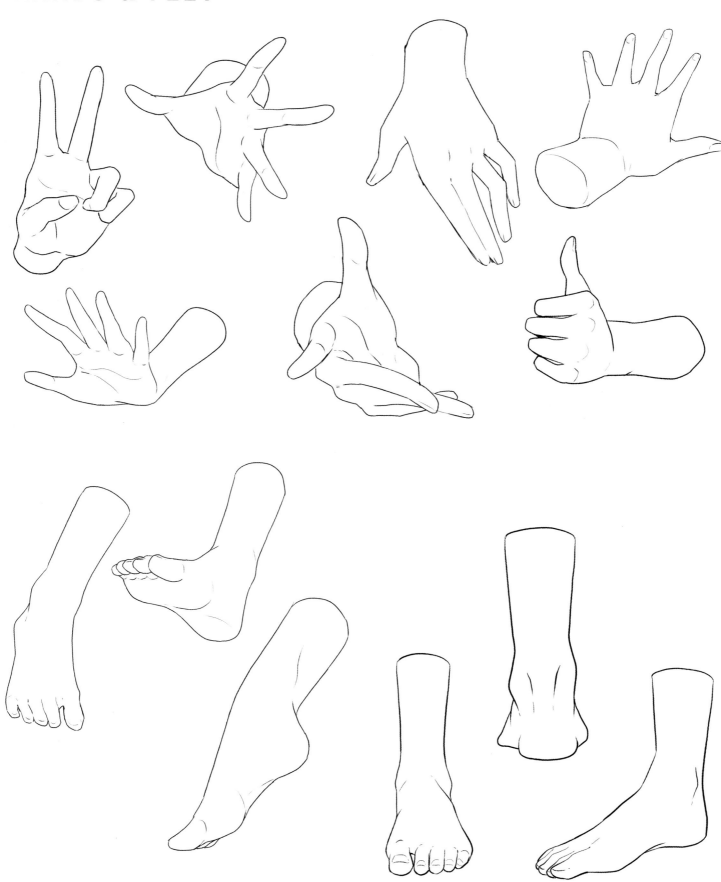

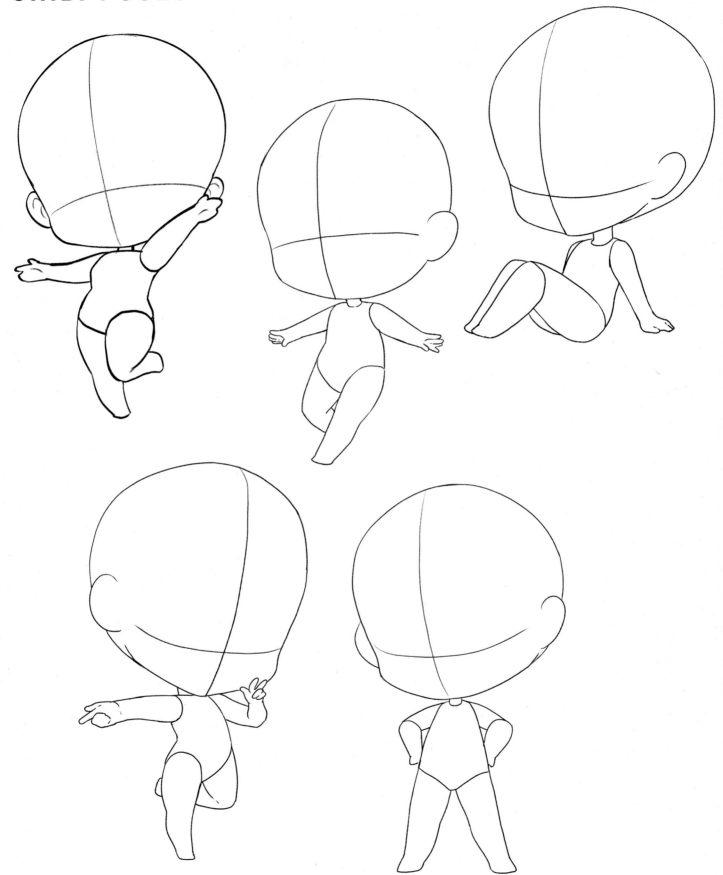

ABOUT THE ARTIST

Talia Horsburgh is an Australian illustrator known commonly online by her internet alias Orbitalswan (@orbitalswan). From humble beginnings tracing anime DVD covers on her bedroom floor as a child, to completing a bachelor of fine art at the Queensland College of Art in 2016, Talia has a passion for creating and teaching art. She has taught drawing workshops to teams from notable companies such as Google, YouTube, and Pinterest. Talia has been featured in various magazines and was recognized "Best in Western Talent" by *NEO* magazine. When not in her studio, Talia can be found playing with her two children at their Hervey Bay home in Queensland, Australia.

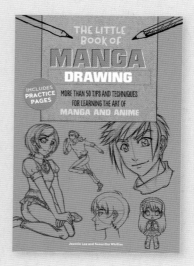